A compilation of wisdom and insights
inspired by the life of Lisa Anne (Mel) Miller

Be Like Mel

22 Secrets to Living a Badass Life

Cassandra,

So yproud of YOU,
my badass daughter!

Love,
Mommy

Foreword by LeeAnn Shattuck • Edited by Sherre' DeMao
Published by SPARK Publications

Be Like Mel: *22 Secrets to Living a Badass Life*
Edited by Sherré DeMao

For permissions requests, please contact Alex Miller at alexmiller120@gmail.com.

Designed, produced, and published by SPARK Publications
SPARKpublications.com
Charlotte, North Carolina

Print Backgrounds by: Anna Hapova / Ayaruta / Crazy Lady / Dzmitry Bandarenka / Irina Bogomolova / Leavector / Loftpearl / Sunny Designs / TabitaZn / shutterstock.com

Cover photography by Cass Bradley.

Casebound, October 2021, ISBN: 978-1-953555-15-1
Library of Congress Control Number: 2021915908

This book is dedicated to Brooks Alexander Miller;
the grandson that Mel never got to meet, on this Earth at least.
Brooks, when you are old enough to read (and old enough to read the
more colorful language used in this book), you will know how brilliant, kind,
and extraordinary your granny was to a circle of hearts, minds, and badass
believers in the difference a single life can make.

Contents

Foreword

No words can sufficiently describe what it feels like to lose "your person." That closest of friends with whom you could entrust your greatest hopes, your craziest dreams, and your deepest fears. That one friend you know you could call at 2 a.m., if needed, and say "I need your help. Bring a shovel, a blanket, and a bottle of vodka."

And the only question she would ask would be, "What kind of vodka?"

When I lost my father unexpectedly in 2009, my family and friends tried to make me feel better with platitudes like "He's in a better place now," "It will get better with time," or "Please let me know if there is anything I can do." In some cases, these tokens were said without really meaning it, because there's not really anything that anyone can do when you are grieving. Mel, on the other hand, called me and said, "I'm so sorry. This totally sucks. What do you need?" I told her, "I just need you to come sit with me and drink and not judge." She said, "I can be there in an hour. What beverages do you want me to bring?"

And sure enough, she showed up in an hour with a hug that only Mel could give and a big bottle of vodka. We sat on my porch and drank until about 2 a.m., just talking about anything and everything. Not about my dad, but about normal things, wherever the conversation led us. She didn't try to make me feel better. And in NOT trying, she's the only one who did. That's when I knew that Mel was My Person.

Mel was the one person I could talk to about anything. I trusted her implicitly with my craziest ideas, my toughest challenges, and my darkest fears. I could also count on her to give me her brutally honest opinion and call me out on my bullshit when I needed it.

Mel Correll Miller wasn't just MY person; she touched the lives of thousands of people with her love, light, passion, and boldness. She was fiercely loyal and protective of the people she loved and cared about. Losing her has left a gaping hole in many of our hearts and in our lives. But knowing Mel, she would expect us to pick up the slack and be that person for each other.

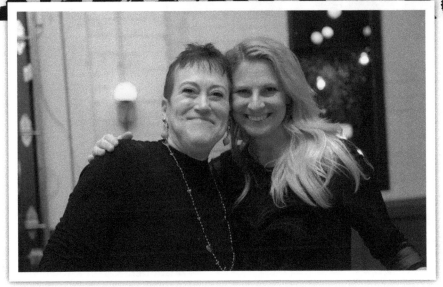

MEL AND LEEANN SHATTUCK. PHOTO BY RAE IMAGES

She created Business Sorority to support and empower the badass group of women that she collected over the years. She taught us what Sisterhood truly meant. She created a #LoveArmy. She created the very organization that she would need to fight a disease that dared to attack her.

Mel may be gone from this Earth, but what she stood for lives on in each of the lives she touched and in how we are different because we knew her and experienced her authenticity.

We must continue to love, support, encourage, and empower each other. And even call each other on our shit when needed. That's what Mel would do and did. We must continue her legacy so that, through us all, she will live. Always and forever. While I am blessed to write the foreword, it is because of the many lives she touched and forever changed that this book was born and had to be written. Inside these pages is a compilation of lessons and stories from Mel's sisterhood, family, and friends.

Mel tailgated the fuck out of life, and left an imprint so unforgettable that we knew more lives needed to know her, what she stood for, and gain wisdom from her.

#belikemel

LeeAnn Shattuck

Introduction

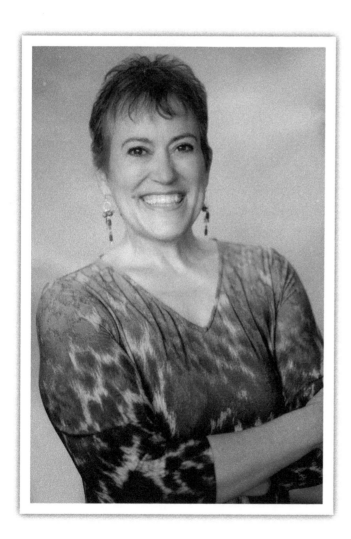

To say Lisa Ann (Mel) Correll Miller had a following would make you think she was one of those social media influencers. You know, where selfies get you likes and sharing is about posts, not about actually sharing.

No, that is not the type of influencer we are talking about here. Mel would likely add to this, "Hell No!" And that's why she was so loved. She was an influencer of a different kind. She influenced in every moment by her actions and her convictions, not just when people were watching.

It was during her Memorial Tribute Service in May of 2020 that we all realized that she was influencing us again. As memory after memory was shared of the difference she made and the lives she touched, one of her long-time friends, Lori Fike English, said, "I had been thinking and thinking about how I could honor Mel going forward and how I would make sure I never forgot how important

We have no doubt by the end of these pages, you too will be inspired to "Be Like Mel."

she was to me and all of the things that I learned from her." Lori proceeded to share a quick list of lessons learned from Mel, because as she shared, "my brain works in bullets, not in eloquent words like so many others here." Lori's hope was that these lessons that meant so much to her would resonate with others who knew her. And perhaps together we could all spread a little Mel to others in the future."

When Lori finished her list, you could feel the nods through the virtual memorial airwaves. LeeAnn Shattuck said, "We could all share so much, from the serious to the funny in the lessons we learned from Mel. We could probably compile them in a book called 'What Would Mel Do?' And it would be a great book for getting through life in a totally badass way."

The idea sparked at the memorial of more people being inspired to "Be Like Mel" continued to grow. When it was shared that a book was going to be created, so many wonderful people stepped up to give their time and talents. This included LeeAnn Shattuck pulling the stories together and compiling them, Sherré DeMao editing, photographers Cass Bradley and Ebony Stubbs donating stunning photos of Mel, and numerous friends and family contributing the secrets to living a badass life that are shared in this book. Fabi Preslar and her publishing firm, SPARK Publications, produced this book at no cost to Mel's family.

Like Mel, this book is anything but typical. It is written from a tapestry of stories and memories about Mel from those who knew her, loved her, and were forever changed by having known her and been loved by her.

That's why you will see "we" throughout, as our collective voices share the wisdom and spunk of Mel.

And we have no doubt by the end of these pages, you too will be inspired to "Be Like Mel."

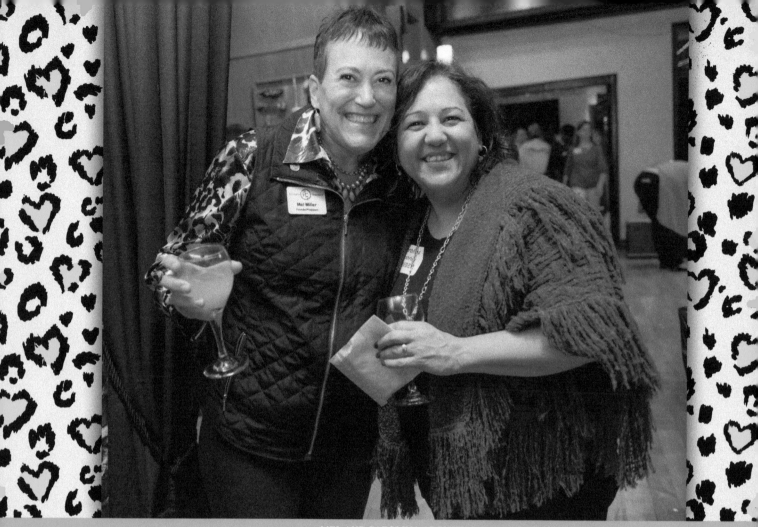

MEL AND CAROLINA APONTE

1. Mel taught us that hugging was symbolic of being all in when it came to engaging and getting to know a person. Mel understood the power of a good hug, and she exemplified showing love and support to others with a heartfelt embrace.

Be All In, Starting with Hugs

Chances are, because of COVID-19's influence, you judged this first secret. Perhaps you stepped back in a social distancing demeanor or reached for your mask at the thought of someone advancing towards you for a hug.

Anyone who knew Mel knew she was a hugger. COVID had just made its appearance when Mel left this Earth. And, no, it wasn't because of COVID. It was that other "c" word.

And yes, we acknowledge that hugging has become almost taboo at the time of the composing and publishing of this book. But like Mel, we are eternal optimists and believe that hugging will make a comeback in a big bear-of-a-hug way. So yes, we are kicking off these secrets with hugging, and the real secret to what it represented to Mel.

Mel gave the best hugs. Not quick, polite hugs. As longtime friend Lori Fike English shared, "Mel gave the best big, squeezy, awesome, tight hugs. And she would say more with her hugs than a lot of people could say with their words."

Mel's hugs made you feel better, no matter how crappy of a day you were having. Mel always knew when you needed a hug. She intuitively knew when the smile on your face was just a brave façade

covering up the real shit that was going on in your life. For Mel, hugs could be the answer to what someone needed. A simple all-embracing hug.

Hugging quickly became the standard greeting at gatherings of Business Sorority, the organization Mel founded that you will learn more about throughout this book. Most business groups honored the more formal and standard greeting of a professional but boring handshake. At Business Sorority, sisters and guests alike are greeted with a genuine smile and a big hug. Those loving, warm welcomes are part of what has set Business Sorority apart from other groups, especially networking groups. Guests would immediately realize that this group was different, and that it was a place where they could feel safe and supported. They quickly learned that they didn't have to be "on" all the time. They could be vulnerable and real. They could be themselves.

Mel always knew if anything was "off" with her peeps. From the minute LeeAnn Shattuck walked into the room at a Business Sorority luncheon, Mel knew if LeeAnn was in her "car chick mode" or hiding behind a mask of stress that day. Mel had a way of sensing something was wrong. In the case of LeeAnn, Mel greeted her with her trademark hug, and then looked LeeAnn in the eyes and said, "Your energy is off today. What's wrong?" When LeeAnn responded, "Just life shit," Mel would simply nod her understanding and say, "Well, I love you, and if you want to talk later, there's a bar upstairs. You know where I'll be." This was followed by a second, even bigger, squeezier hug.

Mel also understood and respected that not everyone is a hugger. She got that sometimes it's cultural or that some people grew up in a family that did not show their affection through physical touch. And she even was astute enough to consider that some others may have experienced some form of abuse or trauma that made them fearful of social touch.

Every time Mel met a new person, she would ask, "Are you a hugger? 'Cause I'm a hugger. But if you're not a hugger, that's OK. I'll respect that. I just wanted to give you fair warning, just in case."

Mel knew that even those who were uncomfortable with physical contact could still benefit from the positive energy surrounding them. Many non-huggers in her circle learned to happily both give and accept good hugs because of Mel's genuine, infectious love. Hugging went from being uncomfortable to being embraced, literally.

One of the hardest parts of losing Mel during the COVID-19 pandemic was that we couldn't get together and give each other the big, squeezy hugs that we desperately needed; the ones she gave with total abandon.

However, we know now that being "all in" can still happen even when hugging is on hiatus for a little while. Because being all in is about how you express yourself and relate to others in a deep and meaningful way. And also, in a way that is unique and special to and for them.

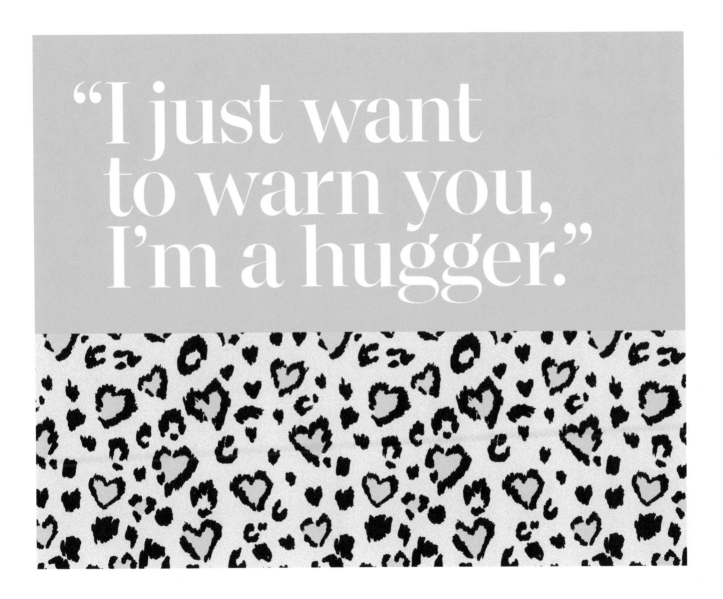

"I just want to warn you, I'm a hugger."

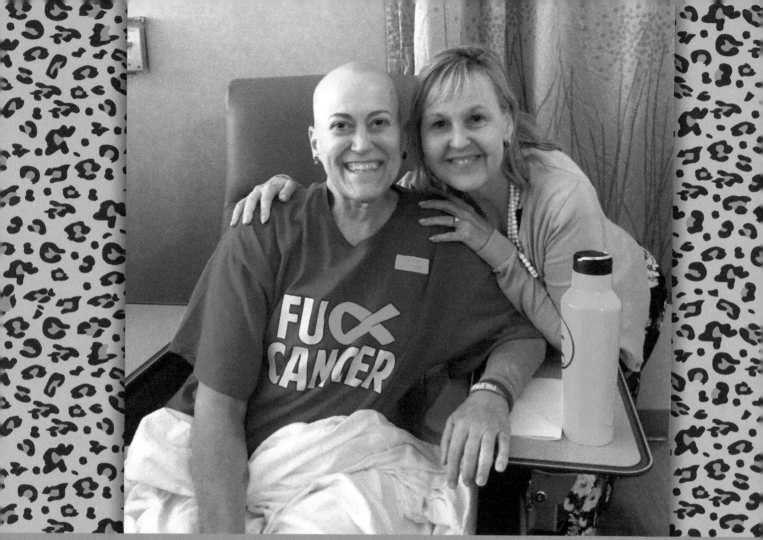

MEL AND ROBIN LEZOTTE

2.

Mel taught us the importance of giving and receiving love as well as asking for help when we need it. She taught us how to show up and fight for our sisters and to always have one another's backs.

SECRET

2

Love Fiercely

It's easy to take relationships for granted. We may feel love and affection towards someone, but that is not the same as expressing it. We get wrapped up in the minutiae of day-to-day life and forget that love is a verb. We need to make the effort to show our love to the people who are important to us on a regular basis. We need to show our love sincerely and in the right ways, so that people perceive it as authentic.

It was no secret that Mel loved her family and friends. But she didn't just love. She loved balls-to-the-wall, no stops, full speed ahead with every fiber of her being. She loved openly and without fear. Everyone knew exactly who Mel loved and how much she loved them. There was never any question; Mel loved with a capital "L." Love that beautiful is something we should all give and be lucky enough to receive.

Mel also believed that receiving love is just as important as giving it. As women, we aren't always good at receiving the love that is offered to us even when we are good at giving it. Sometimes we feel we are being selfish by accepting love, or that we are just "taking" or being needy. Sometimes we feel that we are just not worthy. But receiving love isn't just about you. Mel showed us that love is a two-way street, and by accepting the love you are given, you are in turn giving back to the giver. You are allowing them to experience the joy of giving and loving. It's a feedback loop that blesses both the giver and the receiver, creating an overall feeling of happiness, peace, and acceptance for everyone.

Mel was keenly aware of *how* each person received love. She knew who was a hugger and who was not. She knew who needed to hear the words and who needed to see love in action. She knew who just needed some quality time with her. She knew who perceived love through gifts, and she put great care and thought into choosing the tokens of her affection for each person.

Lianne Hofer attended a Business Sorority luncheon as a guest on what happened to be her fiftieth birthday. Mel, who had known Lianne through other networking groups, met her at the welcome table and presented her with a birthday gift.

"She gave me this beautiful yet simple bracelet," Lianne warmly recalls. "She made me feel so special, even though I was not a Business Sorority member."

Mel also knew that sometimes, when life sucked, you just needed someone to sit in the suck with you. There were just a handful of friends who received the "Please don't say 'I'm sorry'" email from Sherre' DeMao when she shared the news of her second eldest daughter's cancer diagnosis, and Mel was one of those friends. In that email, Sherre' emphasized that it wasn't about being sad or sorry, but to simply know that this is what is going on, and that she appreciated that each of her friends whom she knew would have her back through this difficult time. A couple of days after that email, Sherre' received a custom-created card with the blaring phrase on the cover, "I love you more than bacon!" And inside it stated, "And I love bacon A LOT!" Along with the card's message was a heartfelt note from Mel that stated, "Need a shoulder. I'm there. Need someone to just sit with you to vent. I'm there. Need a bottle of wine, a meal, or anything else. Day or night. I'm there."

Mel was fiercely loyal to and protective of those she loved. If someone had constructive criticism or had an issue when doing business with one of her friends, that was one thing. Mel understood that people, even her people, sometimes made mistakes. She would always listen to the situation and give feedback on how to handle it. She also was not afraid to confront a friend who needed the feedback in order to improve. Part of loving fiercely is calling those you love out on their shit when needed. It also meant that if someone bad-mouthed one of her friends unjustifiably or with total disregard, she would put that person in his or her place right then and there.

Loving fiercely became a crucial part of the Business Sorority culture. It was so crucial that Mel created a leadership position called the "Sister Liaison." It was a role that evolved over time within Business Sorority, created out of a need Mel noticed. In one year, Mel saw one Business Sorority sister lose her father and another sister's house catch fire while two other sisters were battling cancer. "I wanted those sisters to feel surrounded by the love and support they needed," Mel said.

The purpose of the Sister Liaison is to be the point person responsible for making sure that a sister has whatever she needs, whether that's meals being delivered, an avalanche of cards, emails, and text messages expressing support, or just love and prayers being sent and expressed. One recipient of this outpouring of loving support, Kirsten Aymer, spoke up at one of the Business Sorority luncheons after experiencing its impact. She said, "I didn't even know many of these people, but they showed up when I needed them. It was a damn Love Army!"

From that moment, "#LoveArmy" became our label on social media, and the hallmark of the organization's true meaning behind "growing your circle, heart, and mind."

The Love Army has implemented meal trains for grieving families or for sisters who have just given birth. The Love Army has donated clothing, toiletries, and household items to a Sister who lost her house in a fire and given a Sister and her daughter a place to stay when their second-floor water heater came crashing through the ceiling into their living room at 2 a.m. one morning.

Little did Mel know when she created the Love Army that she was creating the very thing that she would need ten years later. When she was diagnosed with breast cancer, her Love Army kept her company running while she was undergoing her chemo treatments and sporting "Fuck Cancer" t-shirts.

She found herself on the receiving end of the biggest, fiercest Love Army ever.

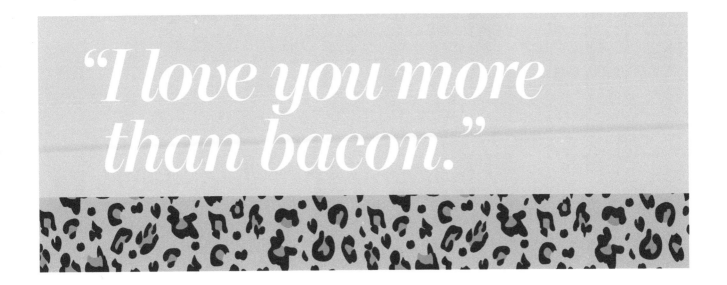

"I love you more than bacon."

MEL AND JULIE TACHE. PHOTO BY BUSINESS SORORITY

3.

Mel taught us that honesty is more than just telling the truth. It's being real, open, and authentic. It's saying what you mean and meaning what you say. Through her actions and words, she helped us see that honesty creates trust and makes genuine relationships possible, secure, and lasting.

Tell It Like It Is

Mel never seemed to have a problem telling people what she thought. She believed in practicing blatant honesty.

Blatant honesty is not about being mean, rude, or insensitive. It's being completely honest and letting the truth speak for itself. It's not holding back how you feel and what you think. It's not telling little white lies to make someone feel better or withholding information that might be hurtful. It's telling the truth with love. Being honest isn't always easy, especially when the truth isn't necessarily what someone wants to hear. Because even if it's not what the person *wants* to hear, it's what they may *need* to hear to move forward and grow. Mel believed honesty was not about placating others but empowering them.

As Mel saw it, "You can say anything to someone, as long as you say it with love."

Mel was the one person that so many of us knew we could always go to for advice. No matter who we were, we could trust her with our deepest secrets and darkest fears, because we knew she would not judge us or the situations we found ourselves in. You could share with Mel your craziest dreams and know that she would be your biggest cheerleader. At the same time, we also knew we could trust her to always give us her honest opinion, because 1) she *always* had an opinion, and 2) she would never hold it back. Even if it was something we didn't *want* to hear but *needed* to hear.

In 2014, LeeAnn Shattuck was struggling to grow her car buying business due to challenges with her business partner at the time. Her partner was the founder of the company, but health issues forced her to step back from her responsibilities. Yet, despite not being involved in the day-to-day operations, the business partner refused to relinquish control and would not allow LeeAnn to do what was needed to market and grow the company. As a result, the business was struggling financially and LeeAnn was struggling emotionally.

While sharing her woes with Mel over wine one evening, LeeAnn was just looking for some moral support. In hindsight, LeeAnn admits, "OK, yeah, I was whining." Mel pierced LeeAnn with a stern but loving glare and asked her infamous question, "Do you want me to tell you what you want to hear, or do you want me to tell you what I really think?"

LeeAnn told her that she always wanted her to share what she really thinks and then braced herself for the reality check she knew was coming.

"I know you love your business partner like a sister, but she has been holding you back for way too long," Mel said. "You are that company. It's *your* face and *your* brand as The Car Chick that people know. No one knows the Women's Automotive name. No one knows her name because she hasn't been putting herself out there. You have. People know you. They like and trust YOU. And that's why she's pissed and why she is trying to maintain control. But if she really loved you, she wouldn't hold you back. You need to dissolve that partnership and start your own company under your Car Chick brand. No excuses. You can do it. You can't afford NOT to do it. So, quit whining and put your big girl panties on."

Blatant honesty delivered with love. That was Mel's style. And absolutely what so many people she shared it with needed to hear.

Mel extended her "honesty is the best policy" to her parenting style with her son, Alex. People who saw Mel and Alex together often marveled at the closeness of their relationship. They were the best of friends. Part of that closeness came from the challenges they faced while Alex was growing up with Mel as a single mom. But the strength of their bond was also the result of Mel's blatant honesty with her son as they faced those challenges together. "Don't BS your kids," Mel said. "As a parent, your first instinct is to protect and insulate them from anything bad, but you are doing them a disservice. You need to arm them to deal with life's challenges in a positive way as they grow up. And it creates the openness and trust they need to feel comfortable coming to you when they have a problem."

Trish Saemann bonded with Mel over their shared belief in being (age-appropriately) straight with their kids and in the challenge of raising sons. Trish is also super close to her two teen-aged sons, and she sometimes struggles with teaching them to be strong and kind young men. Trish recalled a conversation she had with Mel one night at a local wine bar where they examined the assumptions our culture often makes about raising sons. "Boys can be emotional too, and they need to know that it's OK," Mel wisely shared with Trish. Mel also reinforced that sensitivity is actually born of strength. "It was so nice to hear from another mom who understood that, and who successfully raised her own son to be a strong and kind man," Trish affirmed.

For Julie Tache and so many others, Mel's ability to be vulnerable herself was the ultimate reason that she grew so close with so many. She also understood being willing and open to being on the receiving end of "telling it like it is."

"I'll never forget a weekend call while I was at my daughter's dance recital," shares Julie, "I hid away [for] almost an hour while Mel shared a decision she was wrestling with that might be very devastating for a colleague she cared about. In the end, after talking it through, it reinforced what she knew she needed to do to be fair and authentic."

Mel knew that part of "telling it like it is" was also acting on one's talk and not just doing all the talking. She exemplified everyday authenticity in her actions, not just in her words.

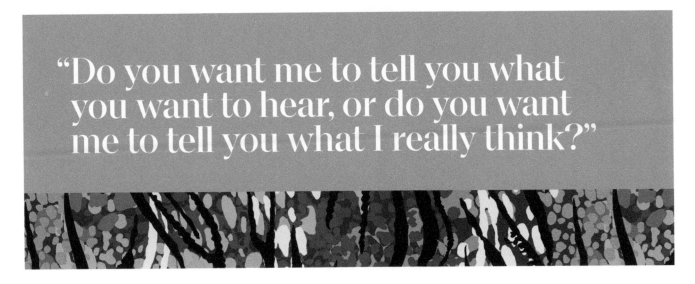

"Do you want me to tell you what you want to hear, or do you want me to tell you what I really think?"

MEL AND WENDY SHANAHAN

4. Mel taught us that networking done right is relationship building, pure and simple. She believed that you only get out of anything what you are willing to put into it, so why not make it count? Especially when it comes to cultivating and nurturing relationships new and old? And the best part is it grows your circle, heart, and mind.

You Are the Only Person in the Room

Mel was the networking queen of Charlotte. She knew everyone. If you needed a resource for anything, all you had to do was ask Mel. Need a mortgage broker? Mel would send you her top three. Need a chimney sweep? No problem. Mel knew someone who knew someone who did that. Need a blingy pink taser to protect yourself? Mel would give you the name and number of that lady who sold personal protection products for women at the Business Sorority holiday party three years ago.

How did Mel know so many good people? She networked. All. The. Time.

"Life is networking," she said. "Having a conversation with the cashier in the grocery store checkout line is networking. Networking happens everywhere. It's just a byproduct of being social."

Mel talked to everyone everywhere she went. You know the type. You may have had a grandfather, aunt, or uncle like that. Or maybe you're that way yourself.. No one is a stranger.

With Mel though, it wasn't just that she networked. It was also *how* she networked: deliberately, attentively, and authentically. She greeted each person with a smile and genuinely wanted to get to know them. She made everyone feel special and important, even when she didn't always have the energy herself.

Every December, Business Sorority hosts a Holiday Extravaganza in lieu of the individual chapter luncheons. We bring in dozens of vendors selling everything from handmade jewelry, pottery, and crafts to organic soaps and personal care products. And chocolate. Always chocolate. It's a great way for the sisters to network with local artists and get all their holiday shopping done in three hours. For Mel and the leadership team, it represents weeks of planning and a long day of setup, management, and tear down.

Several years ago, after a Holiday Extravaganza in Gastonia, Tammy Rojas recalled Mel and a few other exhausted members of the event committee sitting down at the bar to have a much-needed drink. The drinks had just arrived when a woman came in and said, "So-and-so said I needed to come in here and meet you! I have a business across the street."

Mel lowered her head, touching her chin to her chest, and Tammy could tell Mel was thinking "Oh for fuck's sake" because of how tired she was. Then she dug deep and found love to give. Mel shot her head up, looked at the woman with the biggest, genuine smile on her face and gave of her time. She made that woman feel welcomed, special, and like she was the only person in the world in that moment.

Mel believed that networking is just the first step. True relationship building is about taking a deeper dive to develop that "know, like, and trust" feeling with someone. It requires investing dedicated, focused time with that person to not only learn about them, their business, and their values, but also to know how you can help and support them. That's why Mel strongly encouraged everyone in Business Sorority to do "one-on-ones." You can't learn enough about a person and their business to help them, or to trust them enough to refer them, just by seeing them at monthly luncheons. Grab a coffee, do lunch, meet after work for a drink, and get to know each other.

There's a reason Mel scheduled all the Business Sorority chapter luncheons on Fridays. It allows us to stay afterwards, go to the bar, and really get to know one another through more intimate conversations. Those Friday afternoon "after-events" allowed more freedom for us to be real and go deeper, riding on the energy and enthusiasm of the luncheons, the 30-second commercials everyone shared, and the inspiring speakers.

The conversations flowed along with the beverages, and we learned what we had in common and how we were different. We didn't just talk about business; we talked about our significant others, our kids, and our fur babies. We shared funny stories, expressed concerns over current events, and lamented the games lost by our favorite sports teams. Even though it was a group setting—sometimes large enough to take over half of the bar—it was a tapestry of dozens of individual conversations and connections.

Mel made a personal effort to engage with as many different people as possible on those afternoons. She made a point to learn something new about each and every person, whether they were a new guest or an old friend. This is how she expanded her connections and built lasting relationships. Whether you were a member of her inner circle or a part of her larger tribe, she always made you feel important when she engaged with you. It was like you were the only person in the room.

Relationship building to Mel was also friendship building. It wasn't just about business. When long-time friend Kelly Byrnes' mother, Kathy, introduced Mel to Kelly, it felt as if they had been friends for years from the first time they sat down together. Kelly recalls, "One of the coolest things about Mel is she made everyone feel like that."

Kelly credits Mel for teaching her everything she knows about networking. Nicolette Shoop said that Mel showed her how to be truly present with a person. "Mel had that gift of being available and being love, being a force in our lives to call us to be our highest self."

"I wish you could see yourself the way I see you."

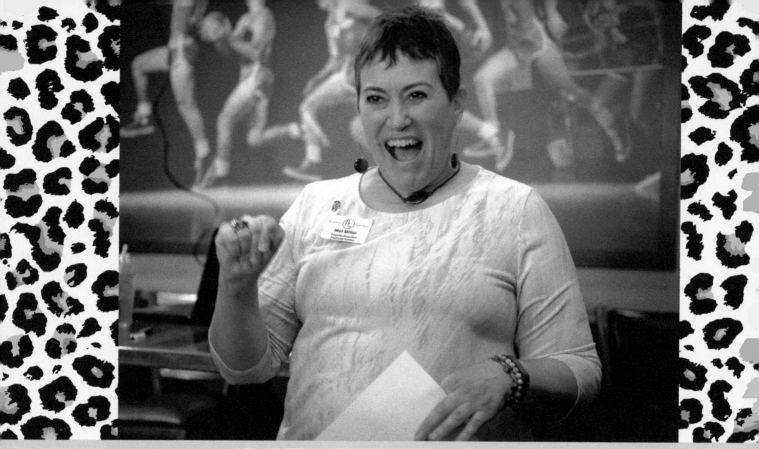

MEL AND HER MAGNETIC PERSONALITY. PHOTO BY RAE IMAGES

5. Mel taught us that a magnetic personality requires two key elements: the ability to attract people, and the ability to be seen as open and approachable by those people. When combined, those two qualities create a positive aura that draws people in and influences them to want to stay connected in a good, empowered way. And when you have that flowing, your tribe will appear right before your eyes.

Find Your Tribe

Y ou've probably heard of a person having a magnetic personality. Mel was that person. She was a master networker with an uncanny ability to attract people. She was like the sun radiating positive energy and drawing people with similar positive energy into her orbit. It seemed effortless, but it was, in fact, very deliberate.

Before Mel founded Business Sorority, she was a member (along with other Business Sorority sisters) in a networking group called Business Leaders of Charlotte, known as BLOC for short. The co-ed group hosted a networking "after hours" the last Wednesday of every month at a private club near uptown Charlotte. Open to both BLOC members and guests, it was one of the premier networking events in Charlotte and a great place to meet new business owners and professional contacts.

Instead of working the room, like most people would endeavor to do at the event, Mel would stake out the largest booth in the back of the room with a few close friends. We would sit back, laugh, enjoy some cocktails, and not *try* to network. Occasionally, someone in the group would say, "Maybe we should get up and mingle," and Mel would reply, "Nah, they will come to us. We don't have to move." And come they did.

Mel's "court," as it became known, was not snooty or cliquey, but welcoming and inclusive. The mantra was, "the more the merrier, so scoot on in!" More daring newcomers would make their way to

the back booth, intrigued by the raucous laughter, and get pulled into the circle. "Y'all look like you're having so much fun over here. I had to come see what it was all about!"

If Mel spotted a more nervous networker who looked uncomfortable talking to people, she would ask whoever held the outside seat in the booth to gently grab that person and invite them to join us. Mel would treat that person like an old friend and make them feel like part of the gang.

Mel made networking look fun, not scary, difficult, or a chore. She emphasized that it was not about the quantity of people you meet, but the quality of those you genuinely connect with and want to connect with again. "If you just have fun with it, you will always be surrounded by amazing people who lift you up. You will find your tribe," she believed.

When you find your tribe, you know it. They are people you really want to connect with on a deep level; people who share similar interests, but who also share similar values and actively provide support to the other members of their tribe. Not every person will be a good fit for every tribe. A tribe will attract the right members, but it will also naturally repel those who are NOT a good fit.

Mel also knew that the value of having a tribe, those trusted partners in life and in crime, is that they would not only have your back but also the backs of those you loved. Julie Tache shared how when Mel's son was a teenager, in her no-nonsense way, she got to the heart of the matter with him by teaching him who he could trust. "She taught him to trust the people she trusted, so he would always know who to turn to and who would look out for him like his own Momma Dukes would."

Mel intentionally built the concept of a tribe into Business Sorority when she founded the organization. Most business networking groups allow anyone to join, as long as you pay your dues and meet any attendance requirements. Not so with Business Sorority. Prospective members are voted on by the leadership team and must be sponsored by a member, similar to a sorority. Women who are interested in the group are permitted to attend up to three events as a guest before deciding whether to submit a membership application.

"After three events, you should know if this group is a good fit for you or not," Mel said. "And we should have a feel as to whether you are a good fit for the group."

Part of finding the right fit also involves having choices. Many networking groups limit chapter membership to only one slot per business category or industry. Mel decided to allow five slots per category for Business Sorority. Why five? "Five just seemed like a damned good number," she

explained. "Three is not quite enough to have diverse choices in each industry. I wanted to provide enough choices for everyone to find the exact resource that they need in each area."

With three chapters, as Business Sorority's tribe continues to grow, there are always choices for everyone. And good choices, too, due to the careful selection process Mel developed and her natural ability to attract amazing, powerful women who would turn around and attract more amazing, powerful women. With such a large tribe, "You won't be BFFs with everyone," Mel clarified. "But you can find your inner circle within this group while also loving, supporting, and helping everyone in the group." In other words, by being awesome, Mel found her tribe and helped many of us find ours as well.

"One more round, on me?"

MEL AND EBONY STUBBS. PHOTO BY RAE IMAGES

6. Mel taught us that by setting boundaries, saying "no," and protecting her time, she had time for the important things in life. She had time to laugh, time to love, and time to be loved. And most of all, the time she spent while she was on this Earth was of her choosing.

Protect Your Time

Time is the only truly nonrenewable resource. It's the only thing we can never get back. We can only spend it. And we only have so many years, days, hours, minutes, and seconds to spend. Sometimes less than we think.

As a single mother, Mel learned the value and necessity of delegating early on. She had to just to survive. When Alex was grown, Mel was still running a full-time financial planning business and a growing networking organization. She hired an assistant to help her run her business. She built a strong leadership team to help her run and grow Business Sorority. And she excelled at "voluntelling" people to get stuff done, so everything didn't fall onto her plate.

Mel was good at setting boundaries. Many of us in Business Sorority are entrepreneurs. As business owners, we often let clients or customers run all over us and determine our schedules. Taking phone calls and answering text messages and emails at all hours. We feel like if we don't respond immediately, we'll be viewed as unresponsive and lose that client, or they will think we are lazy and not doing our job. So we don't set boundaries, and as a result, we don't have time for the most important things in life, like family, friends, and hobbies. We don't have "down time" for ourselves, so our physical and mental health suffers. We don't protect our time.

Protecting your time also means managing that time and knowing when your brain is best at doing different types of tasks. Neuroscience shows that people are more productive at certain times of day, and that "productivity heat map" is different for each person. When are you most creative? When are you best at talking with people? When are you best at crunching numbers or doing more analytical tasks? Some people are "morning people" and do their best creative work, like writing, designing, or podcasting early in the day. Others like to start their day by engaging with people – making sales calls or having breakfast meetings.

Mel was not a morning person and frequently was caught stating, "I am not people-ready until after 9 a.m." She spent most mornings watching the markets and making trades, while reserving her afternoons for meeting with clients and networking. And when the workday was done, she shut it off.

Mel was a giver of herself and her time. She always gave of her time to those she loved, no matter how busy she was. If you needed her, she would be there. No questions asked. She also protected her time fiercely. Family was always her number one priority, and her favorite activity was spending time with her son, Alex, and his wife, Emily, who she loved like a daughter. She also made time for herself, curling up with a good book and her beloved dogs.

She set boundaries for herself and set expectations with her clients up front, so they knew that she would not return business calls, texts, or emails after 5:30 p.m. Instead of thinking she didn't work hard enough, they respected those boundaries, and they respected her for setting them.

Ebony Stubbs deeply respected Mel for teaching her how to best invest her time when Ebony felt overwhelmed by starting a photography business while still working a full-time job.

"Mel reminded me to 'keep first things first' and stay focused on what's really important," Ebony shared. "Not the everyday minutiae that can weigh you down but nurturing your relationships with family and friends. At the end of the day, that's what will give you the energy to keep moving forward to achieve your goals."

Mel never wasted time on things that were negative or dragged her or others down. Mel wasn't afraid to say "no" to people, especially those she called "emotional vampires" who did nothing but suck the energy out of you without filling you back up. This is where she drew the line when it came to giving of her time to others. If you came with drama, gossip, negativity, or an attitude of taking, then just turn around and don't let the door hit you in the ass when you leave.

"I'm going to shut the world off and go listen to Kool and the Gang."

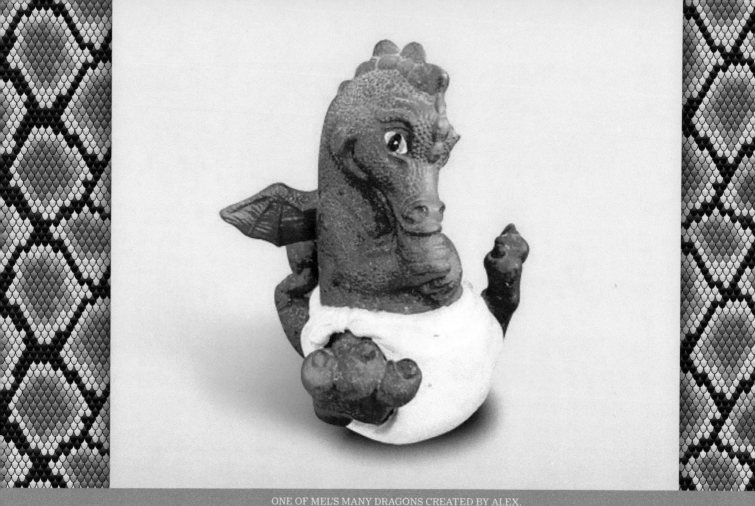

ONE OF MEL'S MANY DRAGONS CREATED BY ALEX.

7. Mel taught us to find our own dragon; what was symbolic, meaningful, and inspiring to us, and then go crazy with it in our lives. Proudly display it, and share the story behind it with total abandon. It makes for a memorable reason to enjoy being with you, and it also makes it easy to buy gifts for you!

Find Inspiration in Unusual Places

el collected dragons: dragon pictures, dragon figurines, dragon candle holders, dragon incense burners, dragon light switch plates. You could not go pee in her house without one of those mythical lizards staring at you.

Some of the dragons were given to her as gifts. Some she purchased at our annual outing to the renaissance festival. Business Sorority is the only group known to tailgate at the renaissance festival. Her mother, Peggie, and her son, Alex, even made several of them for her. Her favorite was a blue dragon eating Oreos that Alex made when he was a little boy. She had over one hundred of these winged creatures adorning every room in her house.

To some, it may have seemed creepy until you understood why.

Mel was born in the Year of the Dragon, per the Chinese Zodiac. The Dragon is the fifth of all zodiac animals. Legend says that the Jade Emperor determined the order of the zodiac by ordering the animals to race. Everyone expected the fierce and strong dragon to win, yet he finished behind the rat, ox, tiger, and rabbit. When the Jade Emperor asked the dragon why he was so late, the dragon replied that on the way he saw a village that was suffering from a drought, and he stopped to create rain for them.

Women born in the Year of the Dragon are passionate, mesmerizing, and strong. If you underestimate them, they will stand up and kick your ass. They are confident in themselves and serious in what they do. They are honest, sometimes to a fault, and they are brave. They tackle problems head-on and don't mess around. Feminism and gender equality are important to them. They are very independent and do not need a life partner to feel complete, yet they need love and respect. They are fierce protectors, and family is central to their well-being. Mel was most definitely a dragon.

Mel could be a little intimidating when first meeting her, even to her oncologist, Dr. Heeke, of the prestigious Levine Cancer Institute.

"Mel came to me at a moment of crisis, having been hospitalized with life-threatening anemia. I remember being rather intimidated when I first met her and surprised that her room was FULL of friends and family. I was nervous to say the right thing, with a dozen eyes carefully watching my every move," she shared. "I came to realize the entourage was not just a one-time thing, as is more typical in cancer care. Multiple friends and family members were present to support her at every single appointment. It was clear Mel had done something right in her life to deserve that level of adoration and loyalty."

For Mel, dragons were symbolic of who she strived to be for herself and for others. They served as an everyday reminder of the inner strength one can possess, that fire in the belly that one can passionately act upon, that unexpected heart hidden within the layers.

After her diagnosis, a song that really spoke to Mel was "Whatever It Takes" by Imagine Dragons. Some of the lyrics were Mel through and through: "Whatever it takes; 'cause I love the adrenaline in my veins; I do whatever it takes. 'Cause I love how it feels when I break the chains."

"*Dragons are NOT creepy.*"

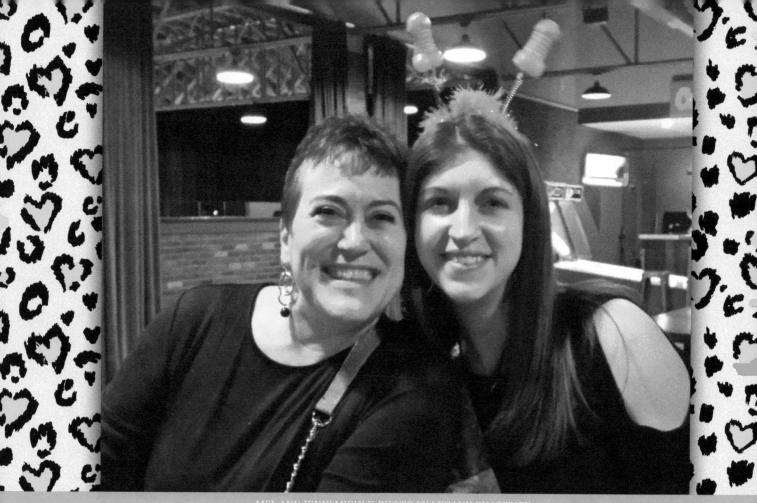

MEL AND JENNI MIEHLE. PHOTO BY LEEANN SHATTUCK.

8.

Mel taught us to love, appreciate, and accept people for exactly who they are, no matter where they came from or their current circumstances. She taught us that if there were people that did rub us the wrong way, to accept them and simply choose not to engage. It's okay to choose who to be with or not be with. It is not okay to judge.

Accept People for Exactly Who They Are

Mel was a shrewd judge of character. Despite her unusually large numbers of friends, she was selective about the people with whom she surrounded herself on a personal day-to-day basis. She had no patience for drama queens, emotional vampires, or salesy people. Yet she always saw and accepted people for who they were. She never tried to change anyone. Instead, she filled her circle with different types of people with different personalities, different skill sets, and from different walks of life.

Jenni Miehle was one of those people. Jenni is an introvert, and not the type of person you would expect to connect with a gregarious personality like Mel.

"I had attended a couple of Business Sorority lunches and I could definitely feel that there was something different and special about the group," Jenni recounted. "I had just started my business and was brand-new to the whole networking thing, which terrified me. I wasn't sure if I was 'legitimate' enough to apply for membership in Business Sorority. I also found Mel a little intimidating, as I often do with people who are MUCH more outgoing than I am. But I ended up sitting next to her at the "after party" on my second visit, and I was surprised at how warm, friendly, and welcoming she was."

After that meeting, Jenni bravely filled out the application and brought it to the next meeting, where she nervously handed it to Mel. Breaking into her signature big grin, Mel waved one hand and said, "We already talked about you. You're in!" Jenni admittedly had struggled a lot at various times in her life with making friends and feeling like she belonged. "Those words of acceptance, delivered with Mel's megawatt smile, felt like a bright ray of sunshine to me."

Although their personalities were incredibly different, Jenni never felt like Mel wanted to change her or turn Jenni into a more outgoing networker like her. It was quite the opposite; Mel saw the value in their different perspectives and even encouraged Jenni to accept the leadership role of Membership Chair in Business Sorority. Mel believed that Jenni's "quieter" approach would be beneficial in attracting diverse personalities into the group. And of course, Mel was right!

Mel's friendship, support and acceptance gave many people the courage to just be themselves. We don't have to pretend to be someone we're not. We don't have to change to "fit in." Nor should we expect others to do so.

One of the things Mel would often say in her welcome speech at a Business Sorority luncheon is, "We all love our adult beverages here; however, if you want to join us at the after party and are a non-drinker, that's okay too. We won't judge you if you don't judge us!"

Non-drinkers could still be a bit intimidated by the name "Business Sorority," especially going into the super-secret "Initiation" ceremony held each July. Claudia Abbott was one such "pledge."

"I'm not a partier and was never in a sorority in college," Claudia explained. "I was nervous about Initiation, but also excited to get a 'big sister' with whom I could, hopefully, bond." Claudia was thrilled and surprised to be assigned Kirsten Aymer as her big sister. Not only was Kirsten a non-drinker, but the two women shared many common interests. It was a perfect match.

When Claudia asked Mel, "How did you know to match me with Kirsten?" Mel replied, with that knowing and slightly mischievous glint in her eye, "I have magical ways of doing things."

Mel's "magical ways" were simply a deliberate and loving acceptance of each woman for who she was, without asking or expecting her to change to fit into the "sorority" mold. Matching two non-drinkers with outgoing personalities made both Claudia and Kirsten feel accepted and appreciated instead of judged for their choice to abstain from the adult beverages.

Being "judgy" was considered taboo in Business Sorority, and it was at the very core of why Mel was so loved by so many. She didn't judge. Period. On one of her Facebook posts around her

birthday in 2019, she shared a meme and posted, "You know who you are. Lol." The meme stated, "If you don't know my story, keep your mouth shut. If you do know my story, that makes you an accomplice. Keep your mouth shut."

"*If you're a non-drinker, that's ok. If you don't judge us, we won't judge you.*"

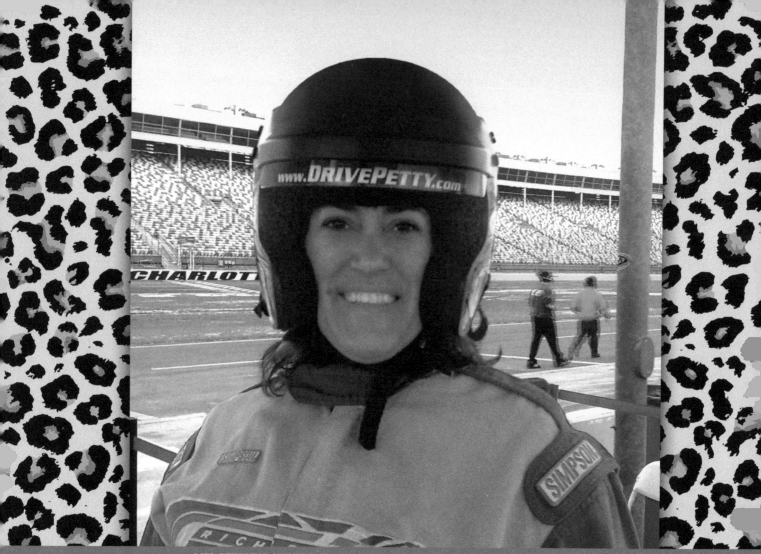

MEL STEPPING OUTSIDE OF HER COMFORT ZONE. PHOTO BY BUSINESS SORORITY.

9. Mel taught us that you will never know how truly amazing you can be unless you are willing to step outside of your comfort zone. On the other side of fear is the person you were meant to be and become.

Get Out of Your Comfort Zone

Fear is both a natural and essential part of life. Without it, we humans would not have survived. Fear was what told us to run when the saber-toothed tiger was chasing us. It protected us and stopped us from doing too many stupid things as we continued to evolve. It kept us alive. The real purpose of fear is to motivate action, but it can also hold us back. Fear can stop us from taking action and keep us from growing both personally and professionally when we allow it to have a hold on us.

Mel's superpower was the ability to see in others what they could not see in themselves. She saw our potential and what we could achieve if we would just find the courage to overcome our fears and step outside our comfort zone. We just needed a little faith in ourselves and our ability to realize bigger things. And if we didn't find the courage ourselves, she would find it for us.

If you knew Mel for more than five minutes, you were probably "voluntold" to do something. If you were bold enough to present an idea for a new or improved process at a Business Sorority leadership team meeting, Mel would say, "That's a great idea. Who's going to own that?" While looking straight at you, her eyes hypnotizing you into volunteering to run with it.

If Mel thought you would be good in a particular role or at doing a certain task, she would invite you to lunch, talk about this exciting opportunity, and flatter you into accepting it. Whether you thought your skills and experience were up to the task or not. It was next to impossible to say no to Mel.

In 2018, Mel approached her friend and Business Sorority sister, Tammy Rojas, about becoming the Director of the North chapter of Business Sorority. Tammy was flattered that Mel would consider her for such an important leadership position, but as a marketing and branding professional, she was accustomed to working behind the scenes. She replied, "Thank you, but that's not what I do. I don't get up in front of groups of people and talk."

Mel looked Tammy in the eye and said, "But you can." And she did.

Mel also encouraged people to grow by learning new skills, even if those skills terrified them. It's why she implemented the Book Club (where you don't have to read the book) and the Speakers Group in Business Sorority. Mel knew that the fear of public speaking affects a majority of the population. Yet she also knew that speaking is one of the most powerful marketing tools for business owners (or anyone for that matter) to increase their visibility, build trust, and grow their personal or business brand. But very few small business owners take advantage of this tool, because they are terrified of public speaking. They don't know what they would talk about, and they doubt their own expertise in their field, or they don't think anyone would want to hear what they had to say. They're afraid to put themselves out there and risk judgment by others, or they're afraid they would freeze up and look like an idiot. These are all valid fears, but Mel knew that with proper training and practice, all these doubts and fears could be overcome.

When Mel started Business Sorority, she asked (voluntold) Julie Tache to head up the Speakers Group, because she had years of experience in radio and television that had beaten the fear of public speaking out of her long ago. As a former sportscaster for the Carolina Panthers and voiceover talent for radio commercials, Julie was the perfect person to teach a workshop on how to manage your fears around public speaking.

This workshop has truly transformed "no way am I getting in front of an audience" women into confident, impassioned speakers who share wisdom, insights, or their stories in compelling and inspiring ways. We now have a basic introductory level workshop focused on getting comfortable with speaking in front of one or many and a Speakers 2.0 level workshop led by LeeAnn Shattuck that helps members prepare a signature speech and get on the speakers' circuit.

Those of us who got to know Mel as an adult and professional tended to take it for granted and assume that she had always been this fearless extrovert. But she really wasn't. She considered herself an ambivert and was a homebody at heart, often preferring the company of her dogs to people. She, too, was forced outside of her comfort zone and voluntold to take on a role that she never saw herself doing.

Mel began her career in the financial services industry in a behind-the-scenes role as the office manager for CNA Insurance. In this support role, Mel learned the ins and outs of the insurance business and ended up training all the new insurance agents who started with CNA. The broker-in-charge saw how well Mel trained his agents and decided that she should be in a sales role herself. Mel didn't want to be in sales. She liked the regular business hours, and the steady paycheck gave her and her young son, Alex, a level of financial stability they had never known. She didn't want that to change.

She didn't want the unpredictability of a commission-based income. She didn't want to put herself out there and have to drum up business. But her boss decided that he needed another salesperson more than he needed an office manager and forced Mel to step outside of her comfort zone. She sucked it up and learned to do sales. And found that she was good at it.

As American author and speaker, Neale Donald Walsch, famously said, "Life begins at the end of your comfort zone." People rarely embrace change unless they are forced to embrace it. Growth and expansion never come from a place of comfort and security; therefore, success is not achieved by staying within safe boundaries. In being forced to step outside her comfort zone and into a completely new role, Mel embarked on a new career path and a new journey. In doing so, she discovered a passion for empowering others to grow and succeed.

As her daughter-in-law, Emily, shared with deep admiration, "Mel has never been afraid to do her own thing and be true to herself. Her creative, brilliant mind was anything but mainstream. She was never meant to be ordinary. She truly was one of a kind, and I feel honored to have even known her, let alone be her daughter-in-law."

"Underestimate me. That will be fun!"

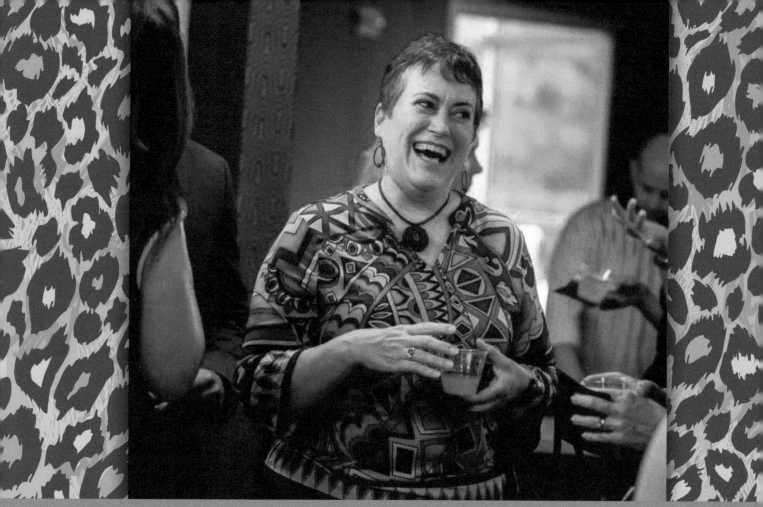

MEL CONFIDENTLY LAUGHING AT A SITUATION. PHOTO BY NESHA PAI.

10.

Mel taught us that whatever you want to overcome, you can—with intention, focus and dedication. She believed that having confidence in yourself and being able to express it in a way that draws people in and gets them excited is a skill that can be learned and embraced.

10

Toot Your Own Horn

Women are not always good at self-promotion. Whether it is talking about their business, asking for a raise or promotion, or seeking media coverage for their accomplishments, women struggle with "tooting their own horn" much more than men. Sometimes it's a lack of confidence or the dreaded "imposter syndrome" that holds us back. Society also has a double standard, telling women to be humble and not to brag while rewarding men who do just that. It's a key reason for the gender gap in earnings and corporate leadership. Mel thought it was bullshit.

Mel believed everyone had something unique and special to offer and sometimes just needed a little encouragement and know-how to share it with the world. She also knew that many people were uncomfortable with talking about themselves. "Well, if you don't toot your own horn, who's going to do it for you?" is something she has said more times than one can count.

This gave Mel the idea, around the same time as the formation of the Speakers Group, for offering a workshop on how to do your 60-second commercial speech. Mel had seen LeeAnn Shattuck share her expertise in how to create an effective speech for your business and asked LeeAnn to develop a 60-Second Commercial workshop for Business Sorority. Speed networking rounds were a part of every luncheon, and talking about your business in just one minute was extremely challenging and stressful for most business owners. Mel believed that public speaking was a key area where women business owners

really needed to be pushed outside their comfort zone to grow, whether it was for a one-minute "this is who I am" or making a presentation that could take one's business to a whole next level of wow.

There is no better example of the impact of this workshop than the growth that occurred with Becca Bazzle. Mel met Becca back in her BLOC days and brought her in as one of the original founding sisters of Business Sorority. Becca is an amazing massage therapist who began her career working for one of our other BLOC friends, Laura Murphy. To say that Becca was a wallflower would be an understatement, and Laura took it as her personal mission to help Becca come out of her shell. Any time at a networking event when Laura was called upon to talk about her business, Essential Therapy, she would literally pull Becca off of the wall, shove her into the spotlight and make her give the commercial. Becca was terrified! But she bravely stumbled through it in a quiet, shaking voice.

When Laura moved to Charleston, she sold Essential Therapy to Becca. Becca knew that now, as the business owner, she no longer had the safety net of her mentor to fall back on. She knew that she had to learn to speak effectively and confidently if her business was to succeed. So, she signed up for the very first Business Sorority 60-Second and Speakers Group workshops, and she attended nearly every single one for close to ten years. Most sisters attend the workshop once, maybe twice. They learn a lot, get some great takeaways, and then do a lot of practicing and tweaking on their own to develop an effective elevator speech or to become a confident speaker.

Becca dedicated herself to mastering the skills that were once so far outside her comfort zone that she could barely utter two words in public. Now, she is an adept 60-second commercial maven and a polished speaker who regularly gives her signature talk at other networking events in Charlotte. Today, she doesn't hesitate to stand up and speak about her business or about the various aspects of Business Sorority when called upon. Becca became Mel's poster child for the success of the 60-Second Commercial and Speakers Group workshops and for learning to own her awesomeness.

Mel took every opportunity to "brag on her sisters" and promote the heck out of Business Sorority, yet she sometimes hesitated to promote herself and her financial planning business outside of one-on-one meetings. LeeAnn Shattuck noticed that Mel never participated in the speed networking rounds at the Business Sorority luncheons. Mel justified her non-participation by claiming, "It's not about me, and I have to time the networking rounds and make sure lunch comes out on time."

Never hesitating to turn the tables and call bullshit on her best friend when appropriate, LeeAnn pointedly told Mel, "Delegate someone else to keep one eye on the buffet table, use the timer on your

phone, and get your butt into a networking round. Everyone knows you are the leader of Business Sorority, but they may not know that you're also a great financial planner. You are doing them a disservice by not letting them know how you can help them with their money." After that, Mel included her role as a financial planner for Ameriprise in her introduction at Business Sorority and actively participated in at least one speed networking round.

"You need to own your awesomeness."

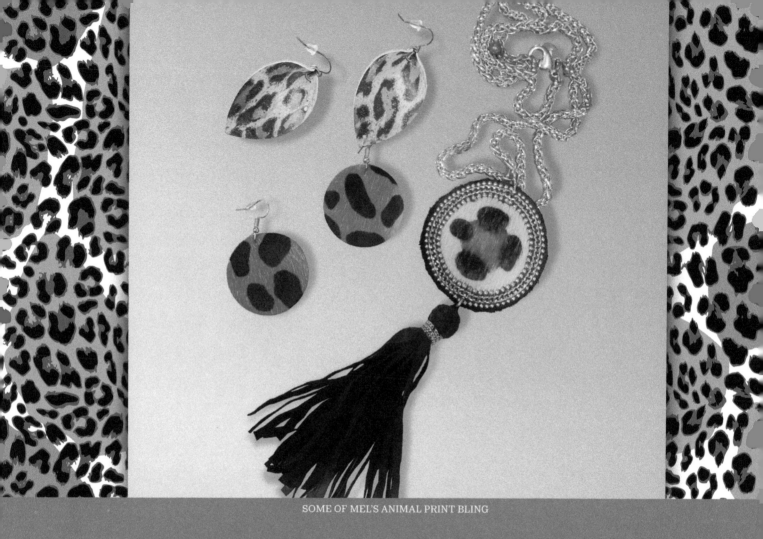

SOME OF MEL'S ANIMAL PRINT BLING

11. Mel taught us that what you wear should bring out the best in you and make an impression on others that is undeniably special and worth remembering. She taught us that it isn't about extravagance as much as it is about expression.

11

Animal Prints Equal Sassy

We've all heard the old adages about dressing for success. "You are what you wear." "Dress for the job you want, not the job you have." "Look the part."

Not everyone does this. Whether it's due to financial limitations, lack of fashion sense, or just not giving a shit, many people don't put a lot of effort into their business wardrobe. That's why many businesses have some sort of dress code. Otherwise, most people would show up in the pajamas they wore to Walmart the night before.

Mel knew that pajamas were LeeAnn's comfort zone, work-from-home attire, but she also knew that what you wear has an impact on your mindset and how productive you can be. While LeeAnn understood the power of dressing from an image standpoint and had no problem showing up at networking events and speaking gigs in her trademark hot pink dresses, high heels, and custom gear jewelry as The Car Chick, her work-from-home wardrobe was another matter. Since Mel somehow magically knew when LeeAnn was having a tough day, she would call or text, "How are you doing today? You better not still be in your pajamas. At least go put on some damn yoga pants and a different t-shirt."

Mel knew how to dress for success. She had a unique style that reflected her bold personality. For her, it was not about expensive, designer clothes but outfits that made you feel good, confident, and ready to conquer the world. She loved the vibrant colors and patterns of her favorite brand, Chicos. She preferred the bright blues and greens and the soothing, earthy browns that became the signature colors of Business Sorority. She believed that you could feel strong and confident and still be comfortable at the same time, as evidenced by her collection of colorful palazzo pants and ballerina flats. And she firmly believed that animal prints make you feel sassy.

"There is just something about animal prints that automatically lifts you up and makes you walk taller," declared Mel. "When you are nervous about making a presentation at work or attending a networking event, wearing animal print will elevate you that extra notch and make you feel like you can do anything."

Mel's good friend, Lori Fike English, calls herself a "fashion introvert." As a former marketing executive and serial entrepreneur, Lori is no stranger to success. Yet she has never been comfortable straying outside the black, white, and greys of her conservative wardrobe. One night, Lori ended up crashing at Mel's house after a long night of good conversation and a few too many drinks. She had an important presentation the next day but did not have appropriate clothes with her, as she had not intended to stay the night.

So, Mel took it upon herself to dress Lori from her own closet since they were about the same size. "She put me in a pair of black, cheetah print palazzo pants with a red blouse, a chunky necklace, earrings, and bracelet, and a leopard print rain jacket. I had never worn any of those things in my life, much less together in the same outfit, but I felt like a million bucks," shared Lori, "I was shitting platinum all day. I was bullet proof. I could do anything." Lori nailed the presentation and landed the client.

Mel loved jewelry. Not expensive bling that says, "look at me and my money," but rather big, chunky, colorful pieces that were an expression of her larger-than-life personality and made her smile. "Bling is good. Big bling is better," was her fashion mantra. She also believed in supporting female artists and jewelry makers who created one-of-a-kind pieces. Every year at the Business Sorority Holiday Extravaganza, Mel always made sure to include several jewelry vendors to ensure we would have different types of bling to choose from. Mel could knock out at least half of her holiday shopping while finding at least one new, unique piece for herself.

After Mel died, her daughter-in-law, Emily, invited Mel's family and friends to come "shop" Mel's extensive jewelry collection, so we could each have something special and concrete to remember her by.

Mel believed that wearing a piece of jewelry that belonged to a loved one lets you carry that person with you every day and helps you to channel their energy.

"*Bling is good. Big bling is better.*"

MEL WITH JENNIFER SZAKALY, JINNIE FORSYTHE BROWN, AND TRISH SAEMANN. PHOTO BY RAE IMAGES

12.

Mel taught us that if you focus on giving first and helping others, it will come back around. And not only will your business grow, but your circle of influence and trust will grow too because you gave from your heart.

Give First

When Mel first became a financial planner and started attending networking events, she discovered an alarming trend among small business owners and salespeople. Many of them were only out for themselves. They were so eager to shove a business card in her hand and tell her all about themselves. "It was all me me me me me! Hand out business cards! Generate leads! Get business!" And it pissed her off. They were pushy, self-promoting, and overbearing. They often didn't even bother to ask her anything about HER business. Nope, it was all about *them*, and what they could get. Even worse, the next day, Mel found herself on a dozen new email marketing lists that she did not consent to joining. It's no wonder she initially disliked networking and many networking groups.

Mel was a big believer in "giving first." When she walked into a networking event, she wasn't focused on how many new people she could meet, how many business cards she could hand out or get, or what she could get for herself. Instead, she approached networking with the goal of finding a few people she could help. Perhaps she had a resource they needed for their business or in their personal life, and she could make a connection for them. Maybe they were struggling with an aspect of their business, and she could tell them about a great book she had just read that could help them. Mel usually didn't even mention her financial planning business unless the person directly asked her what she did. She simply focused on finding someone that she could help, and let karma do the rest.

Whether you call it karma, reaping what you sow, or the law of attraction, the "giving mentality" really does work, and Mel was proof. Mel believed that on a social level, giving is contagious. When one person gives of themselves and helps someone else, with no strings attached or expectations of getting something in return, it encourages and inspires others to do the same. The person who receives the help is motivated to return the gesture or to pay it forward, spreading the giving through the community. Giving promotes cooperation, social connection, and trust. So, when you give, you are more likely to get back.

The "give first" mentality was the foundation upon which Mel built Business Sorority. She liked to open every meeting by telling people what we were NOT. "Business Sorority is *not* a traditional networking group," she would profess. "We are not a LEADS group! We believe people do business with people they know, like, and trust. And we provide a forum to build those close relationships."

While exchanging business cards with the women you met at an event was encouraged, it was strictly forbidden to automatically add those people to your email list without their express permission. That was Mel's biggest pet peeve, and a sure way to kill your membership application for Business Sorority! It's also why Business Sorority members must be sponsored by an existing sister to join. Mel wanted to make sure that prospective members understood the "give first" nature of the organization.

Mel practiced "giving first" every day of her life. Whether she helped one of her financial clients find a good roofing company, gave a friend some much needed advice, or made a good connection for a new business owner, Mel was a helper. In fact, she gained such a wide-spread reputation as a connector in the business community that she was nominated and received the prestigious "50 Most Influential Women" award by the *Mecklenburg Times* not once but twice. The last time was in May of 2020, just a few days after she passed away.

In return for her generosity, Mel's circle of people never hesitated to give back to her when she needed help. LeeAnn Shattuck recalls a time, early in their fifteen-year friendship, when Mel asked for help regarding her son, Alex.

"I know your business is helping people *buy* cars, but I really need you to talk Alex *out* of buying another car!"

Alex, who was just eighteen years old at the time, loved cars and tended to want to buy a new one every six months. In doing so, he had dug himself a not-so-shallow financial hole. Yet he refused to listen to his mother's advice, despite her being a professional financial planner. LeeAnn did not hesitate to give

Alex a reality check, free of charge, and help set him onto a path of responsible car ownership. Years later, when Alex had paid off his car and had a solid income, he happily utilized The Car Chick's services to purchase a new vehicle, and LeeAnn had a client for life.

Mel understood that helping others was the key to happiness, prosperity, and living a purpose-driven life. As the old Chinese saying goes, "If you want happiness for an hour, take a nap. If you want happiness for a lifetime, help somebody."

"What do you need? How can I help?"

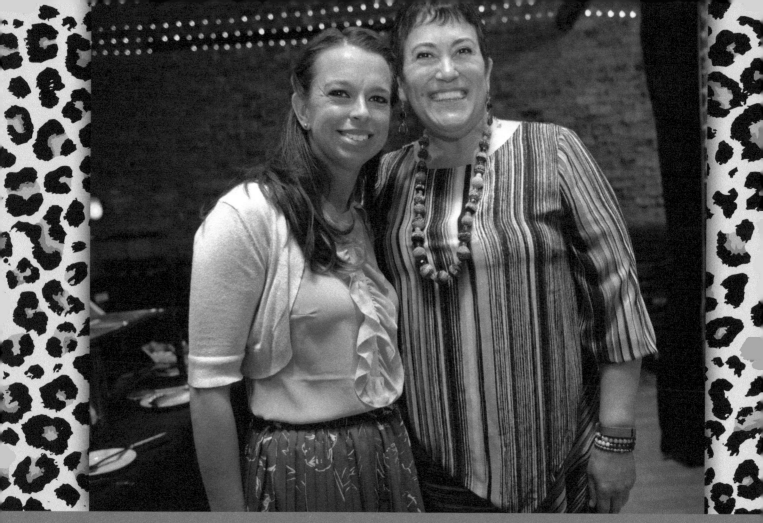

MEL AND ANGELA SIMCOX. PHOTO BY RAE IMAGES

13. Mel taught us to be more mindful, to focus on the moment and to just laugh at the idiocy of others, while trying not to be one of them. She also taught us to always read the whole fucking email.

Multitasking Is Bullshit

People can be idiots. It has nothing to do with intelligence – even smart people do stupid things. We lock ourselves out of the house; we forget to put the gas cap back on the car after refueling; we spend twenty minutes searching for our glasses only to find them on top of our head.

We don't do these things because we are stupid, we do them because we are not paying attention. We are always rushing around, trying to get too many things done in too little time. Get work done. Run a business. Get the kids to school. Run errands. Keep the household running. Get more work done. We're always thinking about the next item on our to-do list instead of the one we are currently doing. It's exhausting, and we suck at it.

As far as Mel was concerned, multitasking is bullshit. It doesn't work, and it actually makes us less effective. It creates a lack of mindfulness, and that lack of mindfulness is what makes people idiots.

Even though we can all be idiots sometimes, we also tend to have a low tolerance for idiocy in others. Mel was no exception. She hated driving in Charlotte traffic and kept up a colorful, running commentary about all the idiots on the road. Even with the no texting while driving rules, people were still paying attention to everything *other* than the road. Or at least, that is the way Mel felt while attempting to make it from location A to location B at any given time.

It also frustrated her to no end when people forgot to follow through on something they promised to do simply because they "got busy." And she had a particular pet peeve for what she called "damn skimmers" when it came to reading emails. And why do people skim-read emails? Because they are in a hurry, doing several things at once, trying to be multitasking ninjas.

The annual Business Sorority Holiday Extravaganza required an insane amount of planning, much of which fell to Mel and the social director, Angela Simcox. They had to coordinate as many as fifty vendors, arrange for extra parking at the already tight venue, Dilworth Neighborhood Grill, and put together over one hundred swag bags prior to the event. Over the years, Mel and Angela developed effective processes and procedures to ensure the event ran smoothly for both vendors and attendees, with clear instructions to each documented in detailed emails. These emails clearly stated when and where to drop off any items to be included in the swag bags or as raffle prizes (Angela's house, no later than three days prior to the event! Items brought the day of the event will NOT be included!) The emails told the vendors by what time they needed to arrive at the event venue to setup (no later than 9 a.m.), and where they should park (clearly marked on a map).

Did all the vendors read the email? No. Of course not. Mel and Angela spent the day before the event responding to emails, phone calls, and text messages asking, "What time do I need to be there? Where can I park? Can I bring something for the swag bags?"

The first few years, Mel let these "damn skimmers" frustrate her. As a result, she was severely stressed and was unable to enjoy the holiday event. Then she realized that she couldn't control what other people did (and did NOT do.) She could only control how she reacted to the situation and how she let it affect her. So, instead of allowing the idiocy of others to cause her stress, she decided to just shake her head and laugh. And to simply reply, "Please read the ENTIRE email. All the instructions are in there. If you would quit skimming and read the whole thing, you will find that your questions have already been answered."

Mel encountered the same problem in her financial planning business. Compliance regulations required that she speak on the phone with a client whenever she needed to make changes to their portfolio and get a verbal approval to make the necessary trades. Her assistant would send out an email to each client, explaining that Mel needed to discuss changes to their portfolio, and listed the days and times that Mel had set aside on her calendar for those conversations. Clients were instructed to call Mel during one of those time windows, and ONLY during one of those windows.

But damn skimmers are everywhere. Even LeeAnn, who was one of her Business Sorority leadership team members and also a client of Mel's, admits to being one of the biggest offenders of skimming. "I didn't even skim the email. I just read the subject line, and then decided that Mel needs to speak with me, and grabbed my phone, and called her right then and there, when I received the email! Seeing my name pop up on the caller ID, she answered the phone already laughing."

"You know, you are one of the only people who can get away with this," she said. "It's a good thing I love you, because you are a damn skimmer!"

"If you don't swear while driving, then you aren't paying attention."

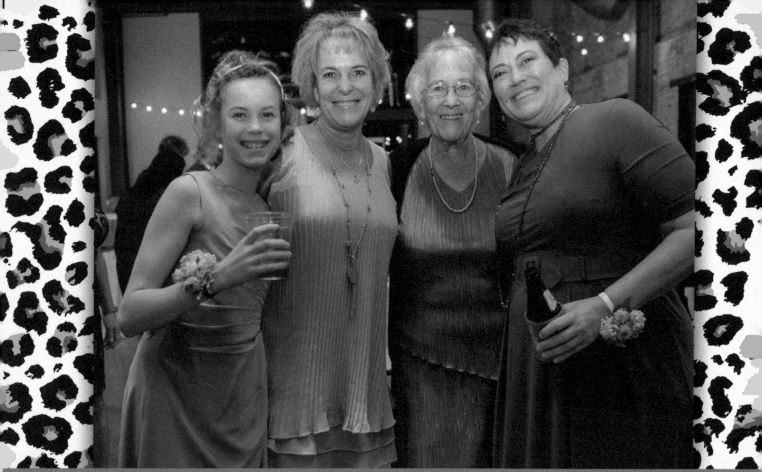

MEL WITH BLAIR (NIECE), LAURA (SISTER), AND PEGGIE (MOM). PHOTO BY RAE IMAGES

14.

Mel taught us that no matter what life hands you or someone tells you, things don't have to be a certain way unless you choose to let them. She inspired each person she touched to dream big, and never lower your expectations just because someone else's were lower or not in agreement with yours.

Don't Settle. Period.

Mel was always determined to do things her way, from the age of two until the day she departed. You couldn't put her in a box. She wasn't just stubborn (well, OK, maybe she was a little stubborn), she was a natural leader with strong beliefs and opinions about the right way to do things, which usually meant HER way.

Her mother, Peggie, recalled a day when Mel was five or six years old. She was in the backyard playing with a half dozen kids from the neighborhood. Peggie watched as her little girl stood in front of the other children, pointing her finger at them, and declaring in no uncertain terms, "This is MY yard. If you play in my yard, you have to do what I want to do, and play by my rules."

Mel always lived life on her own terms. When she didn't like the rules, she changed them. Even with her name. Her birth name wasn't Mel; it was Lisa Anne Correll. Her mother had wanted to name her Melanie, but her father didn't like it. So, they settled on Lisa.

Lisa was a troublemaker as a child. She was stubborn and headstrong and liked to push the boundaries, just to see if she could get away with it. She was rebellious and never listened to anyone. Telling Lisa that she could not do something pretty much guaranteed that she would do it. And then she would dare her mother to punish her for it. Lisa rebelled so frequently that her mother finally resorted to one spanking a day to cover everything her defiant daughter had done that day.

Part of Lisa's rebellious behavior stemmed from being the youngest child for the first twelve years of her life. She felt that she was always being compared to her older sister, Laura. Laura was always referred to as the "perfect" child in the family. Like many oldest children, Laura was studious, responsible, cautious, well-behaved, and always trying to please her parents. Lisa was frequently asked, "Why can't you be more like Laura?" or told, "Laura never does that!" Lisa felt like nothing she did was good enough because Laura did it better.

Lisa didn't just suffer from the typical youngest child syndrome; her behavior was also strongly influenced by her family dynamic. Her birth father was abusive, both physically and mentally. He lied. He had affairs. He was a control freak who terrorized his wife and young daughters with his constant criticism, bullying, and rejection. It's no wonder that Lisa acted out in anger and frustration. Rebelling and doing exactly the opposite of what she was told to do was her way of exercising control over her life.

When Lisa turned seventeen, she decided that she didn't want to be that troublemaker anymore. She wanted to be a different person, a better person. She knew, from her mother, that her name was supposed to be Melanie. So, she adopted a new identity and set out to make a new life to go with it. Although she never changed her name legally, she would forever be known as "Mel."

The biggest change in her life came in the form of her son, Alex. Alex's father was a musician in a local rock band. They met on the 80s rock and roll party scene, drinking and smoking and doing drugs every weekend until the wee hours. Then Mel became pregnant with Alex. It was like a switch was flipped in her brain, and suddenly there was nothing in the world more important to her than the health and well-being of that precious baby. She stopped everything cold turkey, grew up, and became a mom and an adult overnight.

Unfortunately, the birth of their son did not seem to have the same effect on Alex's father. Despite her best efforts to make the relationship work, their marriage dissolved after three years, and Mel was on her own. She never received a penny of child support or any help raising their son. Alex's father didn't even try to spend time with his son. On his custody weekends, it seemed he would frequently dump Alex on his mother, so he could go party with his band.

Mel was working her job at Bojangles to support herself and her son. Even as a store manager, the hours were difficult for a single mother, and she could only afford rent in one of the most dangerous neighborhoods in Charlotte. It was so bad, with drug deals on every corner and drive-by shootings nearly every night, Alex couldn't even play in his own yard. The power company frequently shut off their

electricity because Mel couldn't pay the bill, and the house was so infested with rats that she often had to stay up all night chasing them away with a broom to keep them away from Alex while he slept.

Mel knew that she couldn't keep living like that, and she refused to settle for anything less than a safe and healthy environment for Alex. She had to find a way out and into that better place for her son. Her financial life finally took that turn for the better when her sister helped her get a job as an office manager with CNA Insurance. Mel finally started making good money and was able to purchase a house in a good neighborhood where she could safely raise her son.

The 19th century German philosopher, Friedrich Nietzsche, said, "That which does not kill us makes us stronger. And to live is to suffer, to survive is to find some meaning in the suffering." Mel's suffering early in her life taught her not only to be strong but to never settle for anything less than the life that she wanted for herself and for Alex.

"If you play in my yard, you have to do what I want to do, and play by my rules."

MEL WITH JULIE TACHE, BECCA BAZZLE, EBONY STUBBS, DENISE CAGAN, AND DIANE MCDERMOTT. PHOTO BY RAE IMAGES

15.

Mel taught us that sisterhood goes beyond bloodlines and is at the very heart of what makes each of us stronger. Having a female tribe who always has your back begins with holding each other up when you need it the most and lifting each other up so you can truly soar.

Strong Women Empower Women

Mel was so passionate about helping women entrepreneurs that she became the Managing Director of a national women's networking franchise for a chapter in Charlotte. Mel quickly found herself constrained by the franchise rules and unable to implement changes or enhancements she wanted to make to better support her chapter members. So, in true Mel fashion, instead of settling, she changed the rules and did things her way.

On a Friday afternoon, following one of the franchise chapter events, Mel and a few of her close friends conceived the idea of Business Sorority and would end up being the founding members of this Mel-inspired vision. They were all sitting around the table venting some of their frustrations with the franchise rules that didn't allow adult beverages. Mel wanted to bring in speakers to talk about challenges that women face in their personal lives, but the franchise only allowed strictly business topics. The idea for having a workshop to help members get better at their "60-second commercials," had been proposed, since speed networking rounds were part of this franchise's luncheon format, but the franchisers said no. Everyone agreed that the female-only focus and the special camaraderie that the "girls club" aspect encouraged was still important, yet Mel wanted more. She wanted to support women as whole people,

not just in business, because it's so much harder for women to separate their personal and professional lives. As a single mother, she knew why it was so important for women to have a tribe of other women to support them, to lift each other up. She wanted to create a true sisterhood for professional women: a business sorority.

The name, Business Sorority, started out as a joke that night, but it stuck because it really captured the spirit of the type of group that Mel wanted to create. "And because, you know, women like to get together for a beverage now and then," Mel joked. But Mel didn't want just another networking group or leads group—like so many other business organizations in town—she wanted a true relationship group.

Shortly after that Friday afternoon powwow, Mel terminated her franchise relationship and started the first chapter of Business Sorority in the neighboring city of Gastonia, North Carolina, which was both close to her home and outside of the non-compete area dictated by the franchise contract. She focused on quality, not quantity, and sought out women who were full-time business owners, not people with hobbies or side gigs, who could help fulfill the Business Sorority tagline of "Grow your Circle, Heart and Mind."

Another important aspect of why the group needed to be different was for all the introverts in the world. She knew how hard and uncomfortable it was to be in a group of people and be expected to share things about yourself. She wanted to create a group where introverts and extroverts could thrive because of a common thread of caring, consideration, and giving in a spirit of uplifting one another.

Fast forward ten years and Business Sorority has grown to three Charlotte area chapters with a #LoveArmy of sisters dedicated to supporting each other in business and in life. Not only did Mel create the exact organization that she had envisioned that night in the bar, but she created the exact organization that she would need to support her years later, when she was diagnosed with breast cancer.

"Don't fuck with my introverts."

MEL AND HER "GRANDDOG," RYLIE.

16.

Mel taught us that logic has its place in the world, but your intuition can point you in the right direction, even if you don't understand it. Instead of analyzing it to death, take a moment to sit with it, and embrace what you are trying to tell yourself.

Trust Your Gut

Have you ever had a feeling about something that you just couldn't explain? Maybe you felt like someone was watching you even though you couldn't see them. Or you just knew that a prospective employee wouldn't work out despite their stellar resume. Women have great intuition. You know, that "gut instinct" that sends a signal to your brain that says, "Hey, dumbass! This is important! Pay attention!" Or "Danger! Danger! Back away now! Don't do it!"

Whether that sixth sense is trying to save your life or just keep you from making a decision that you will live to regret, you should listen to it. And yet, so often, we don't.

As Business Sorority expanded to multiple chapters around the Charlotte area, Mel needed more "sisters" to take on leadership roles. Anyone who has ever run a volunteer-based organization knows how difficult it is to find people who are both willing to fulfill a role and able to do it well. Yet, just getting anyone to fill a role can be detrimental to the organization—not to mention friendships—if that person is not a good fit. Mel learned the hard way about who would be a good fit for the Business Sorority leadership team and who was better suited—whether due to skill, personality, or bandwidth—to a valued committee role. She learned to trust her gut and was rarely, if ever, wrong.

It's why Mel became the go-to person when anyone needed a "gut check." In the case of LeeAnn, she had met someone who was nothing like the "type" she was typically attracted to and yet found herself

surprised by her strong feelings for him. He was completely different from anyone she had ever dated in her life. She had suffered two devastating losses that same year, including her father, and was dealing with anxiety and depression issues. She was questioning if she truly loved this guy or was simply confused by life's gut punches.

So, she turned to Mel, as many sisters would do for advice. She shared with Mel her entire list of pros and cons and explained all the reasons that David was not her "type."

Mel looked LeeAnn in the eyes, cocked her head, and said, "Did it ever occur to you that 'your type' has been wrong all these years?"

No. No, that had never occurred to LeeAnn. After a few moments of awkward silence, Mel said, "Mmm hmm. There you have it. Trust your gut. It is trying to tell you something!"

Mel also encouraged her son, Alex, to trust his gut when making major life decisions. When Alex was nineteen, he told Mel ("Mama Dukes" to him) that he wanted to drop out of college after just six weeks of attending classes. "It just wasn't for me," Alex recalled. "I wanted to get out in the real world and work full time."

"You're an adult now, and you can make that decision if you want to," Mel told Alex. "But you'll have to pay me rent. Every month. No excuses."

Alex made the decision to drop out of Gaston College and pursue a career at AutoBell car wash centers. He had been working there part-time as a crew leader and was being considered for the assistant manager position. Unfortunately, his background check revealed that he had lost his license for thirty days a few months prior for a DUI charge that had been dropped. But AutoBell didn't care that the charges had been dropped, and instead of getting promoted, Alex was fired.

He spent the next several months bouncing around to various odd jobs, but his gut was still telling him that he was on the right path, and his mother continued to support his decision, while he kept paying his rent. Alex soon found a position as a fitness consultant at the Charlotte-based Sports and Fitness Center. "I had always been passionate about Health and Fitness, so it was perfect," Alex said. In less than two years, Alex had worked his way up to the District Manager position.

After four years of working 70-hour weeks, Alex was exhausted and needed a change. His friend and colleague, Kent Schneider, reached out to Alex because Kent's father was looking to hire a new sales rep for his firm, Total Packaging Company. He was impressed with Alex's accomplishments at Sports and Fitness and wanted to meet with him about the outside sales position.

"He told me that I would be selling all types of packaging materials," Alex said. "I thought at the time... what in the hell is that?"

Mel encouraged Alex to trust his gut again and give it a shot. Again, she was right. In his first year with the company, Alex made $200,000 in sales. Eight years later, Alex is now the Vice President of Sales and has sold millions of dollars of packaging materials to clients across the Carolinas.

"I am so glad that Mama Dukes encouraged me to trust my gut over thirteen years ago," Alex said. "I couldn't be happier with my decision. And I was able to buy my own house, so I didn't have to pay rent!"

So, the next time you get that "feeling," trust it. Your gut is rarely wrong.

"I'm suspicious of people who don't like dogs, and I trust my dogs when they don't like a person."

MEL SELFIE

17. Mel taught us that "fuck" was truly the most versatile and powerful word in the English language. According to Mel, it's the Swiss army knife of cuss words, and she taught us to use it well and use it wisely.

Fuck Is the BEST Word!

Many people consider the use of "obscene" language offensive or taboo; however, studies by psychologists and linguists have shown that cussing may be a sign of higher intelligence and greater language skills. People with higher intelligence and education have a broader vocabulary and the ability to pull from that vocabulary the exact right word to communicate their thoughts, ideas, and feelings. Including a few choice cuss words.

Mel wasn't afraid to cuss when the situation warranted it, and the use of colorful language became an unofficial part of the Business Sorority culture. Mel believed that "fuck" was the best word in the whole English language. If you were offended by that particular four-letter word, then Business Sorority probably wasn't the right fit for you.

"You will hear the f-bomb a lot in this group," she frequently said as part of her introduction during Business Sorority luncheons and events. Yet, despite her use of the f-bomb, she used it wisely and it never came across as crass or vulgar. It was simply about being real.

Mel wanted Business Sorority to be a place where women felt safe to have authentic conversations about life and business. And it's hard to talk openly and authentically about those topics without

dropping a few good cuss words here and there—especially when things are not going as planned—and also when they are going like gangbusters.

The Big Bad of swear words became such a normal part of the Business Sorority vernacular that Mel included one of her favorite books, *The Life-Changing Magic of Not Giving a F*ck* by Sarah Knight, as a part of our book club. Knight's book isn't about not caring about people or the world. Rather, it's about not caring so much about what other people think about you. It's about ridding yourself of unwanted obligations, family drama, emotional vampires, peer pressure and stigmas, and anything that does not bring you joy and positivity. It's about setting priorities and boundaries. Mel said, "You only have so many fucks to give each day, so you had better spend them on things that make you happy!" For her, that was her family, her dogs (who she considered family), her Business Sorority sisters and her financial planning business.

It was during one of the infamous Business Sorority discussions in the bar at Dilworth Neighborhood Grill that Mel explained why "fuck" is the best word in the English language.

"It's so versatile," she stated. "It can emphasize a wide range of emotions and be used to fit pretty much any scenario. It can be a noun, a verb, an adjective, or an adverb. It really is the perfect word."

Are you mad? Use it loudly, by itself. "Fuck!"

Are you excited? Exclaim, "Fuck yeah!"

Trying to motivate yourself or your team? "Let's fucking do this!"

Are you shocked or surprised? "What the fuck?"

Need to express your utter disbelief in a situation? "Are you fucking kidding me right now?"

Use it to agree with someone. "Fucking right!" or "Fucking aye!"

Or to give someone fair warning: "Don't fuck with me."

To express fear or dismay to a situation gone awry: "We are so fucked."

And, of course, it can perfectly and clearly convey that you are so over it. "Zero fucks given."

Fuck can be easily combined with other cuss words for emphasis, lending more emotional weight to the overall sentence, such as in "Fuck this shit!"

It can even become part of another word for emphasis, such as "Abso-fucking-lutely!"

And lastly, fuck cancer!

"You'll hear the F-bomb a LOT in this group."

NO

17. Mel taught us that saying no is not admitting weakness or a cop-out, but it is actually a gift to yourself and to whoever is asking—or perhaps demanding—you to oblige yourself to a role or situation that isn't a fit.

It's Okay
to Say No

Mel wasn't a quitter. She always honored her commitments and expected others to do the same. But sometimes—especially as women—we overcommit. Or life happens, our circumstances change, and we no longer have the capacity to fulfill all those commitments. Sometimes we find that a job, a role, or a project turns out to be quite different than we first thought. It is more of a time commitment than anticipated, or it is not in alignment with our values or priorities. Or it simply makes us miserable.

Business Sorority sister, Lisa Speer, was chatting with Mel before they recorded an episode of Lisa's podcast, "Branding BFF" about "Building your tribe." Mel noticed that Lisa seemed unusually tired and drained of her usual energy. Lisa confided in Mel that she was struggling with a leadership role. She was serving on the board of directors for another organization, and the role had turned out to be much bigger and more time consuming than she had been led to expect. The role really required three people, not just one, to do it well. Lisa admitted it was a rough, two-year slog that felt more like a second, full-time job than a volunteer service role.

"Sounds like there isn't much joy there," Mel observed. "So why don't you quit?"

Lisa replied, "Well, I made a commitment, and I have six months left, so I just have to tough it out."

"No, you don't," Mel challenged, and then proceeded to tell Lisa her views on leadership.

During the twelve years that Mel ran Business Sorority, she was constantly working to fill the leadership roles of the volunteer organization. And, of course, she had many missteps along the way. She had to get better at defining the responsibilities and time commitments of the various leadership roles, and she had to keep adjusting—with love.

Mel was a big fan of Jim Collins' best-selling book, *Good to Great*, and his leadership concept of getting the right people on the bus. Yet that's easier said than done. Sometimes, you think you have the right person in a role but later discover it really isn't the right fit, and you either have to move them into a different "seat" or lovingly ask them to get off the bus entirely. More often, she found the person was a good fit for the role, but their life or business circumstances changed, and they no longer had the bandwidth to fulfill the commitment. In those cases, Mel said that she would rather they step down than have them be miserable or to let the job go undone or not done well. In that situation, "quitting" is not a bad thing but rather the right thing to do, both for the individual and the organization. It also opens an opportunity for someone else to step into a leadership role where they may succeed and thrive.

"Leadership should not be an obligation," Mel said. "It's OK to say no. In fact, it's better to say no than to take on or stay in a role that does not bring you joy. Life is too short. If there is no joy in something, then why do it?"

For Lisa, Mel's wisdom opened her eyes to how much she had been leaning into her commitment and what she saw as an obligation versus leaning into her capacity and her joy. She realized that it was a pattern for her, like it is for many women. We have a hard time saying no, especially to the people we love and respect. But when the role or job ends up becoming a source of stress and pain, we feel we must suck it up and do it anyway, instead of pushing back.

After that conversion with Mel, Lisa found the courage to push back on the board of directors regarding her role. She ended up stepping down from the leadership role but in a powerful way. She was able to share her feedback with the board about the true demands of the role and how the responsibilities should really be shared by two or three people. She helped them to restructure their leadership team and clarify their roles and responsibilities, which ultimately benefited the organization. Her "quitting" ended up being a win-win, with both Lisa and the organization feeling good about the decision.

"No is a complete answer."

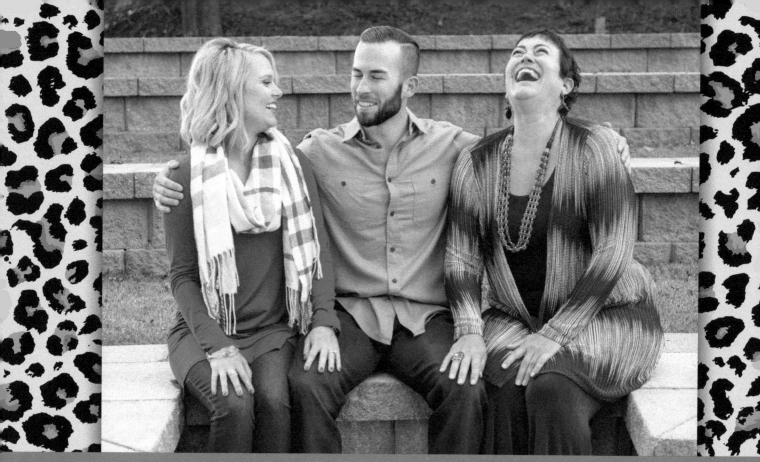

MEL WITH EMILY AND ALEX MILLER.

19.

Mel taught us that when something bad happens or life hands you a bunch of crap, take the time to deal with it. Talk about it. Get it out. Allow yourself to feel the full range of emotions. Even if it means crying into a glass of wine with a good friend and a bartender on a random Wednesday night.

Embrace Your Feelings

As humans, we don't always deal with our emotions, especially the negative ones. We push them away and deny them, instead of giving ourselves space and permission to experience them. To grieve, to be angry, to be scared, to be sad, to really FEEL. We think we must be strong and not show weakness. Or we convince ourselves that we're too busy to take time for our mental health. We just suck it up and get on with life. Sometimes we do have to compartmentalize to survive an immediate crisis. But if we leave those emotions locked in a drawer for too long, they come back to bite us in the butt in sneaky and unexpected ways.

Few things bring up more negative and overwhelming emotions than hearing the words, "You have cancer." First, there's shock, followed by denial and then numbness. Then, once it finally sinks in, there's anger, self-pity, and all-encompassing fear. Mel experienced all these emotions and more—not just when she was first diagnosed with breast cancer, but repeatedly throughout her two-year battle with the disease.

Mel's doctor helped her to address her mental well-being as well as her physical health. "You're scared. You're angry. And you have every right to be," her doctor wisely told her. "Don't keep it bottled up. That will only increase your stress and make it harder for your body to heal. Part of being brave is confronting your fear, so that it doesn't overwhelm you and keep you from fighting."

So, Mel made herself a deal. If she had a rough day, or she got bad news at a doctor's appointment, she let herself feel those emotions.

"I would go home, put on my favorite pajamas, curl up with my dogs and have myself a pity party," Mel said. "I would have a good cry and let it all out." And she would put a time limit on the pity party. An hour; two tops. Then she would pull herself together, take a deep breath, and get back into the fight. She realized that she wouldn't have the strength and energy she needed to fight the cancer if she hadn't given herself permission to experience the whole gamut of sucky emotions.

One of our Business Sorority sisters, Angela Simcox, had suffered a miscarriage and thought that she had dealt with it—emotionally—and moved on with her life. Months later, she found herself in a funk and didn't know why. She had trouble making decisions, was fighting with her husband, and just didn't feel like herself. So, on a Wednesday a few weeks before Christmas, she had a "one-on-one" with Mel.

A one-on-one is a networking term for getting together with another businessperson for the purpose of getting to know each other and your respective businesses to develop a deeper relationship. Or sometimes, a one-on-one is a great excuse to catch up with girlfriends over drinks while deducting your bar tab as a "business development" expense. At Business Sorority, a one-on-one was about getting to know the whole person, not just the business persona.

Angela met Mel at one of Mel's favorite bars in charming Belmont, North Carolina, early in the afternoon. They talked about everything from business to family to current events. Even the bartender joined the lively conversation. After a drink or two (OK, maybe three), the "deep stuff" started to come out.

Angela realized that her "funk" was really a deep sadness about the loss of her unborn child. She should have been six months pregnant and drinking soda, eagerly anticipating a new addition to her family. Mel talked about her desire for grandchildren and her fear that cancer would rob her of that opportunity. Even the bartender openly shared her life challenges. By eleven o'clock, they were all three sobbing over empty glasses. But they each felt their burdens lifted and their hearts remarkably full.

Mel could truly sense feelings and hidden emotions in the people in her presence. And she wouldn't hesitate to be a source of support. She encouraged us to be that for each other and for others so everyone's feelings could be shared openly and confidentially.

"Love you; mean it!"

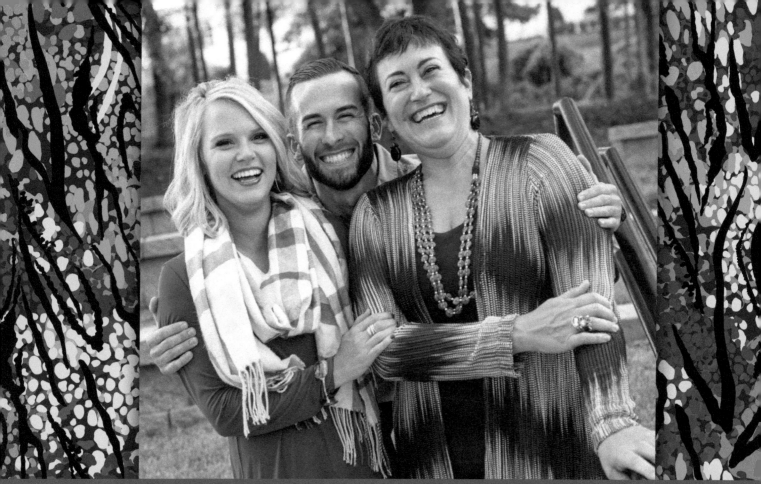

MEL WITH EMILY AND ALEX MILLER.

20.

Mel taught us not to take life too seriously. Even in the most stressful situation, if you can find the funny in it, you have given yourself instant therapy. You have lightened your load just a little bit and released some of that tension that was building up.

Laughter Is Therapy

Just like her smile could radiate through a room, Mel's laughter could bring instant smiles to everyone around her. Mel loved to laugh. She had a wicked sense of humor and delighted in the true joy of laughing out loud; that deep belly laugh that gets the entire room giggling even if they don't know what is so funny.

Mel was a "glass half full" kind of person who could find the funny in just about any situation, even a serious one. She could also make the most ridiculous situations even funnier. From laughing the night away at the Corkscrew in Birkdale Village, to wild adventures at Retrofest in Spartanburg, South Carolina, there was never a dull moment spent with Mel.

The only downside was that she had the memory of a damned elephant. No matter how much wine was involved, Mel always remembered every embarrassing detail of the evening and did not hesitate to give us crap about it the next day. And the next. Yet, we always felt safe letting our guard down around her.

"You knew you could trust her," her close friend, Kelly Byrnes, fondly reflected. "She laughed at you and gave you shit, but she also had your back. Always."

Anyone who knew Mel knew her son, Alex, was her world. And yet, her sister Laura shared that when Mel was growing up, she swore she couldn't stand being around babies and swore she would never have

children. For Mel, that was probably the first example of how the universe has a plan and a bit of a sense of humor. And in this case, the joy Alex brought her, the many bouts of laughter she experienced with him, and the spirited fun they enjoyed throughout their life reinforced the power of laughter.

Mel used laughter as a means of therapy to help her though tough times, especially after her cancer diagnosis. Her favorite and easiest way of finding ways to laugh was simply to be around Alex and his wife, Emily. Mel would spend time at Alex and Emily's house playing cornhole by the fire pit. They watched Mel's favorite television shows like *NCIS*, *Criminal Minds* and *The Voice*. They liked to place bets on who would win each week on *America's Got Talent*, with the loser having to do a Fireball shot. They watched funny movies like *Elf*, *Wedding Crashers*, and *Pitch Perfect 3*. They loved to sing that silly song from the movie, *The Hangover* - "We're the three best friends that anyone could have." Because they were.

Mel not only laughed *with* her family, but she also found opportunities to laugh *at* them. Emily generously provided such an opportunity one afternoon while the three of them were watching a movie at Alex and Emily's house. Mel had brought all three of her dogs over to play with her "grand dog," Rylie. Mel's "middle" dog, Hotch, had always been Emily's favorite, and he flopped on the floor with her during the movie. Emily took the opportunity to pet him and work some of the tangles out of his fluffy hair. She noticed that Hotch had a big clump of hair on his stomach. Thinking it had to be uncomfortable for the poor dog, Emily tried to work the knot of hair out with her fingers. Emily noticed that Mel and Alex, sitting on the couch behind her, were watching her more than the movie. Finally, Emily got up and announced, "I'm gonna go get some scissors, and maybe we can just cut this knot out of his hair, but I may need y'all to hold him still."

Mel and Alex burst out laughing, and Mel exclaimed, "Oh *hell* no! You are NOT going to get scissors!"

"Why not?" Emily asked innocently. "That would be the easiest way to cut out that knot."

"Emily, that is not a clump of hair," Mel told her daughter-in-law. "That's Hotch's penis!"

Emily's eyes grew to the size of saucers as she yelled, "WHAT?! You mean you let me sit here this whole time, givin' the dog a hand job and you didn't tell me?! Damn Millers!"

Now we know why Hotch has always loved Emily the best.

"Gotta find the funny where you can."

MEL IN A SUNSHINE MOMENT. PHOTO BY CASS BRADLEY

21.

Mel taught us that our worth begins with our own belief that we are indeed worth it. She taught us that if we don't value ourselves, we can't expect anyone else to value what we offer and bring to the table. She taught us to be forces in our own brilliance and about the difference we could make on an even bigger scale, if we just believed in it ourselves.

Never Forget Your Worth

Women are bad at knowing our own worth, and we are even worse at owning it. Why? Because we don't value ourselves. We don't ask for the things we need and deserve. Whether that's a promotion or raise at work, a loan or help starting a business, or more support at home, we have a hard time asking for what we want. There is always a part of us that feels that we don't deserve it.

Mel thought that was bullshit. Her struggles early in her life gave her strength and taught her to value herself. By knowing her own self-worth, she helped other women to know theirs. She was constantly telling women she knew that they were amazing and awesome. If she caught someone who was selling herself short, Mel would give her a stern but loving look and say, "If you don't value yourself, no one else will."

Even women entrepreneurs, many of whom started their own companies to escape a male-dominated workplace that didn't appreciate their leadership qualities, still struggle with knowing their worth. Terri DeBoo, a longtime entrepreneur and business strategist, recalled being on the receiving end of such advice from Mel. They met one evening for a one-on-one over martinis, and Terri shared some frustrations with Mel.

"People are always asking me to meet for coffee so they can 'pick my brain," Terri lamented. "I am sick of giving people business advice for the cost of a cup of coffee. This is what I do for a living!"

Mel responded with her trademark "tell it like it is" honesty. "Then stop letting people take advantage of your kindness. You have deep knowledge and experience that you have spent years developing; knowledge and experience that have value. YOU have value, and you must be compensated for your talent. End of story."

Terri and Mel spent the rest of their evening talking about establishing professional boundaries and when "friendly advice" crosses the line into a client conversation. Once she made the decision to know and embrace her worth, Terri didn't hesitate to turn her coffee conversations into sales opportunities. Instead of giving away her valuable business knowledge, she would pivot the conversation and say, "We could go deeper into that if you wish. I normally work on a retainer on three levels." Terri would then go over her services and pay structure, ending the conversation with "Let me know if I can be of any more help to you. I would love for us to work together."

Mel also had a gift for helping women who were struggling with their personal worth. Sintha Steward met Mel during what she describes as the lowest point in her life. Sintha was recently divorced and suddenly faced with having to support herself for the first time. At age fifty, with no college education and no employment history, Sintha was unable to land a job.

"I applied for job after job but kept getting turned down," she recalled. I had been a stay-at-home-mom for twenty-five years, so I had no resume. I couldn't even get a job as a receptionist!"

Like many former stay-at-home moms who suddenly find themselves thrust into the job market with no formal resume, Sintha decided to start her own company. "I had no money to invest in a business, and I wasn't even sure what I wanted to do. So, I ended up doing anything and everything for my clients, just to try to make ends meet. I was drowning—physically, emotionally, and financially."

Feeling worthless, like she couldn't do anything right, Sintha reached out to Mel for advice. When Sintha explained to Mel everything that she was doing, Mel instantly zeroed in on the problem.

"It's not that you aren't good at anything. You're just doing too much. You can't do multiple businesses and be good at any of them. PICK ONE. Be good at ONE thing. You will be successful at it."

Today, Sintha is a successful marketing executive with multi-million dollar clients around the world. "I wouldn't be where I am today if it hadn't been for that one conversation with Mel. She made me believe in myself."

Mel made it her mission to help women realize their worth. "To know that we are all valuable; that we are all worthy of love, respect, success, and happiness; that we can and deserve to live the life we want to live. Sometimes knowing that you are enough gives you permission to grow into more."

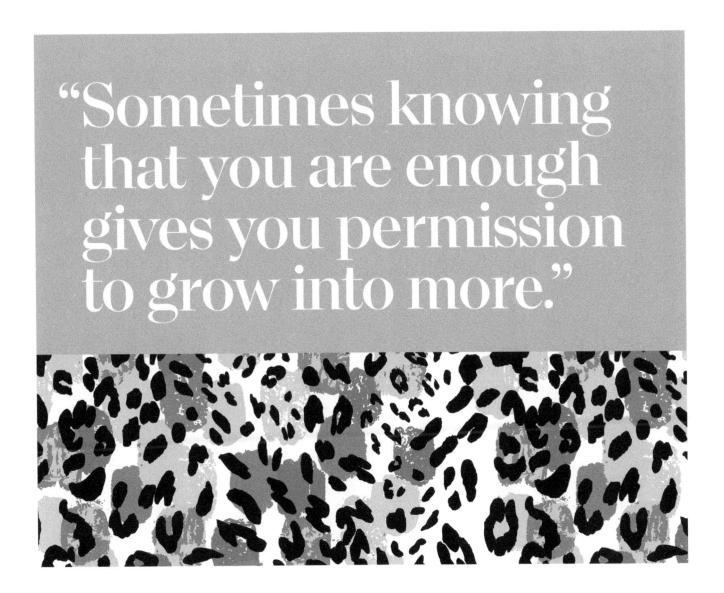

"Sometimes knowing that you are enough gives you permission to grow into more."

MEL WITH EMILY AND ALEX MILLER.

22.

Mel not only taught us to fight like there's no Plan B but, more importantly, to fully LIVE our Plan A. Really embrace it, live it, and be it in every moment. Whether it is how we live our lives or how we are there for one another, there is no doubt that we will proudly and lovingly "be like Mel." *#belikemel*

Live Your Plan A

Adversity is a part of life. We may face marital and family problems, some form of addiction, or financial challenges. We may struggle to start, grow, or keep a business. One way or another, we will have to overcome obstacles—big and small—to survive and succeed in life. It's how we go about facing those challenges that defines us. Do you whine and complain, blaming other people or the world in general for your woes? Do you crawl under the covers and hope it all just goes away? Or do you fight like there's no Plan B?

In her role as a financial planner, Mel believed in anticipating risks and to have a plan for contingencies. Yet, as a friend and an entrepreneur, she pointed out the downsides to being too focused on the Plan B.

"When you know you have a Plan B, you never fully commit to Plan A," she wisely noted. "You know you have a fall back, a safety net, so you don't give Plan A everything you've got."

Mel didn't have the luxury of a safety net throughout most of her life. As a single mother with minimal outside support, she had no choice but to fight every step of the way just to survive. Failure was never an option if she wanted to give Alex and herself a better life. Mel's struggles made her tough and a strong and tenacious fighter. Little did she know just how hard she would have to fight.

As the famous saying from John Lennon goes, "Life is what happens to you while you are busy making other plans." Mel was finally on the path to the success that she had always dreamed about. She had raised a strong, capable, and loving son who had not only found financial success in a job he loved but had met his true match and love of his life in his wife, Emily. Mel had grown Business Sorority to three thriving chapters and was looking into expanding the organization nationally through licensing. She had found a positive and supporting work environment with Alex Bishop's Ameriprise office, and she had a five-year plan to own an Ameriprise franchise of her own.

Then she found out she had cancer—aggressive, metastatic breast cancer. The fight of her life had begun.

Each of us remember the day Mel told us her news that she had been diagnosed with breast cancer. Somehow, we always seem to remember the most horrible moments in life with startling clarity. It may have been at a networking event—of all places—or in a one-on-one, or a phone call.

For LeeAnn, she learned by being pulled aside by Mel at an event. After they had made their rounds networking and sampled every bite of food on the buffet, Mel gently took hold of LeeAnn's elbow and said, "I need to tell you something. Let's find a quiet place to sit and talk." LeeAnn immediately knew that something was very wrong. A tight knot formed in her stomach, and her heart rate shot through the roof. No good news, in the history of the universe, has ever followed the phrase, "Let's find a quiet place to talk."

They found an unused parlor with an assortment of comfy chairs, and LeeAnn braced herself for bad news. She wasn't really sure what form of bad news was coming, as all higher brain function had frozen in fear. Yet, nothing could have prepared her to hear her best friend say the three most difficult words that any person can utter, "I have cancer."

LeeAnn's not entirely sure what happened next, as it was all she could do to remember to breathe. She vaguely remembers realizing that they were in a public place, so she couldn't lose her shit. That would have to wait for later when she was alone. And she remembers thinking that she had to be strong for Mel. So, she simply said, "Fuck. What are we going to do about that?" Letting her know that she had her full support, no matter what it took.

Mel lifted her chin with her usual stubborn determination and responded, "We're going to fight. And we're going to win. We're going to kick cancer's ass."

And fight she did, with everything she had. She never entertained the possibility that she wouldn't beat the cancer. Certainly, she had tough days, and she had doubts on more than one occasion. Especially after receiving disappointing test results and learning that the cancer had continued to spread. She curled up with her dogs, embraced the fear and cried. But she always got back up and recommitted to the fight. She loved life and had too much to live for to give up. Losing the battle was simply not an option.

None of us believed she wouldn't win. We fully expected her to kick cancer's ass, and we did everything we could to support her fight. Her family went with her to every doctor's appointment. Her closest friends took turns sitting with her through her chemo treatments, sporting "Fuck Cancer" t-shirts and networking with the other patients. Mel's dear friend and "get shit done" person, Kelly Byrnes, organized an "I Will Survive!" disco party. Capitalizing on Mel's extensive network of generous (and crazy) friends and her love of disco music, the event raised over $12,000 to help cover medical expenses.

Mel fought even harder after learning from Alex and Emily that she was going to be a grandmother. Nothing could have made her happier. She had a renewed, almost manic energy. She was online everyday shopping for baby clothes, baby toys, baby furniture. It was the hardest secret she ever tried to keep, as Alex and Emily didn't want the news to go public until Emily was further along.

Yet we knew that something was up. Something had changed. Mel was the one who was glowing. She had a non-stop, ear-to-ear smile on her face every single day. Many people thought that the cancer treatments were going well, and she was feeling better as a result. The cancer treatment was NOT going all that well, but she had the biggest and best reason to keep fighting. She just wasn't allowed to tell anyone.

Mel's strength during the hardest times is something we should all strive to replicate.

Mel and LeeAnn met for lunch on Thursday, January 30, 2020. Even though LeeAnn could tell Mel was physically uncomfortable, emotionally she was glowing. She practically had rays of sunshine shooting out of her eyeballs. She tried to play it off as just "having a good day," but LeeAnn knew better. Mel was radiating a joy that LeeAnn had never seen in her before. She looked like she was going to burst. Like she was desperate to tell her something, and it was taking every shred of self-control to NOT say it. Then, suddenly, it all clicked in LeeAnn's head. Alex had just hired her to buy a new car for Emily; something safe and reliable with more passenger and cargo space. She looked Mel straight in the eye, almost daring her to deny it, and said, "Emily's pregnant, isn't she?"

It was like a dam bursting. The truth spilled out of her at a hundred miles an hour. "Oh my god, I'm so glad you guessed! Alex and Emily swore me to secrecy. They don't want anyone to know yet because they just found out. She's due in September. It's too early still, but I am just dying to tell everyone. I'm going to be a grandmother! I'm so excited. I can't wait. I can't wait to see the look on Alex's face when he sees his child for the first time. There's nothing in the world like that moment, and I want that for my son. I have one more reason now to stay on this Earth a little longer."

Unfortunately, the cancer had other ideas, and its spread took its toll on her body. But it could not defeat her spirit or her stubbornness. Despite being in multiple organ failure, Mel drove herself to the hospital, only to be told that there was nothing more her doctors could do. They said that she had only hours, maybe a day or two, left to live. She went home. Hospice was called. Her family and closest friends gathered by her side. Yet she kept fighting and refused to give up, using every lucid moment to tell her family that she loved them. Days passed, then a week.

Mel finally let go on Saturday night, April 25, 2020 amid severe thunderstorms with Alex, Emily and the dogs by her side. We all have no doubt the thunder was the sound of Mel leaving this Earth kicking and screaming. She held on not because she was getting ready for Heaven, but to give Heaven time to get ready for her. No doubt, there are a bunch of angels now being voluntold to do stuff.

Mel's strength during the hardest times is something we should all strive to replicate. Despite her health issues, she never wavered on her willingness to help others and her commitment to her family and her community. Instead of wallowing in self-pity and surrendering to her cancer, she fought back HARD to the very last minute she was on this Earth. She lived her Plan A every minute of her life to the fullest of her capacity. And she did it with the most amazing grace.

"Fight like there is no Plan B"

Conclusion

(A Further Peek Inside)

In October of 2019, in the middle of her cancer treatment, Mel was nominated and received a grant from Charlotte-based photographer, Cass Bradley. The award, aptly named the "Share Your Fearless" Grant encourages women to celebrate both themselves and other women they admire. The grantee then receives a full day experience to celebrate themselves and create an art piece to reflect those experiences back to them.

Mel had been nominated multiple times.

To craft an empowering experience, Cass interviewed her subjects and was able to not only learn about Mel from dear friends, but directly from Mel herself.

Perhaps, there is no better way to close out this book than to share a small portion of those interviews and the legacy Mel leaves in her own words.

Cass: Who are you when you are the very best version of yourself?

Mel: I am giving, loving, and forever positive.

But I do things my way.

I am stubborn as hell, competitive, and I work on me. I want to get better. Like the story of the wolves, I feed it. And feeding that positive energy is a daily choice.

I am a connector. I have always been one. Once I love you, you can't get rid of me!

Mostly, I want to leave a legacy, for my son and his wife.

I am so proud of how my son turned out. He is independent, a great husband, and he works his ass off. I have taught him what he needed. Too many parents are friends with their kids. That time will come when they are grown, but children are children, not peers. He has become one of my best friends.

Business Sorority will also be my legacy. I've really seen it this year. When you show up for people, they surround you with support gifts, meals, company… I feel more loved than I ever have.

Business Sorority is a legacy of integrity, heart, love, giving, and showing the hell up.

Cass: When you are photographed, what can't be missed in capturing who you are?

Mel: I have a smile that lights up the room. Pure joy. When I am around my friends, we laugh. We are goofy and silly and authentic.

But I am also a badass warrior. I want to see myself fighting cancer, shaved head and all. Fuck putting on a hat.

Let's celebrate this!

I want to document all the bruises and embracing the bald.

I am not hiding.

I am not afraid.

About Mel

Lisa Anne "Mel" Miller
September 30, 1964 ~ April 25, 2020 (age 55)

Mel was struck by a simple but profound idea: to build a business organization for women that was based on strong relationships. She was not interested in networking from the standpoint of lead generation as a reason for getting together. She was genuinely interested in connection and empowering women.

A good leader is defined by a willingness to serve and do what needs to be done to finish the job while delegating, empowering, and trusting the people with whom she works. A good leader is always looking to grow and become more self-aware. A leader perpetually seeks to improve herself while encouraging the people around her to do the same. That was Mel.

One of Mel's more recognizable superpowers was to see in others what they could hardly see in themselves. She was very adept at teasing out the best parts of the women she knew and encouraging them to bloom. She inspired all of us to be our best, and in turn, we inspire others to do the same.

In *Hamilton*, Lin Manuel Miranda said that creating a legacy is akin to planting a garden you never get to see. Not only did Mel plant a garden, but she also curated gardeners. The legacy she left is now ours to live.

Mel loved Business Sorority, and she loved each of us. That radiant and infectious smile was genuine, and she will continue to be a true beacon of hope for all of us. She embodied strength, compassion, and light. I know we will all miss her sense of humor, her badassery, and her warmth. Mel's life and legacy are transcendent.

Though we are all impacted by her loss, we must also remember that we are more impacted by her love.

By Trish Saemann

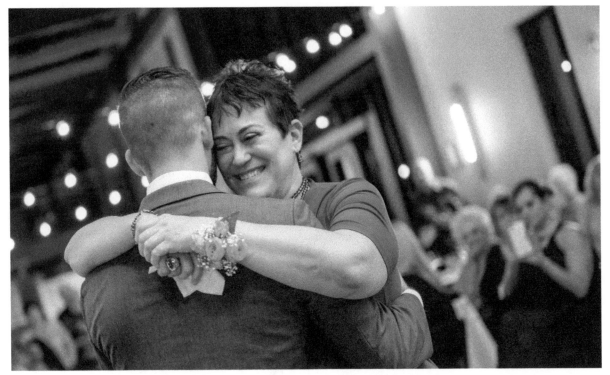

MEL AND HER MAMA LOVE FOR ALEX ON HIS WEDDING DAY.

"Be the things you loved most about those who are gone"

– UNKNOWN

#belikemel

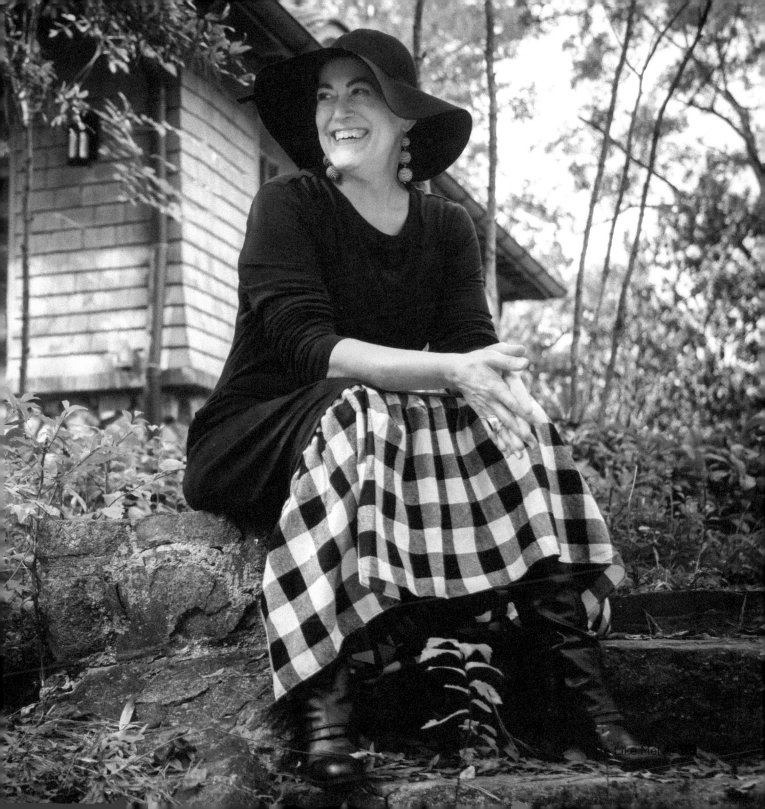

About Business Sorority

Grow Your Circle, Heart, and Mind!

Founded by Mel Miller, Business Sorority is a relationship group. We are not a leads group! We believe people do business with people they know, like and trust. We provide a forum for those relationships to build. We are an innovative network of female entrepreneurs, executives, and professionals. We are dedicated to working together in growing and promoting women in business by building relationships. Business Sorority achieves our success through a commitment to understanding, sharing, and helping each other connect in the community.

We believe each member should strive to grow their business, their leadership skills, and speaking skills and share their abilities within the organization. They should also be able to grow personally. The give and take nature of our group is very important! You should be giving as much as you get in any group you participate in—especially this one!

Our purpose is to provide a progressive network of talent, skills, knowledge, and resources that are accessible to all Business Sorority members to help each other achieve our professional and/or personal objectives. We are a community of women providing unlimited opportunities to women in business.

Contact Us: www.BusinessSorority.com

Business Sorority is a registered service mark of Business Sorority, LLC. Grow Your Circle, Heart, and Mind! is a service mark of Business Sorority, LLC. The Business Sorority logo is a registered service mark of Business Sorority, LLC.

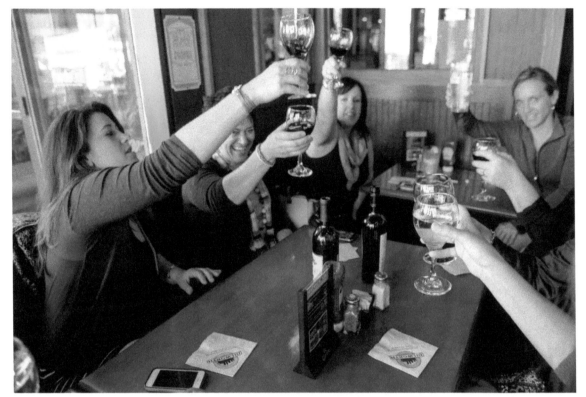

CHEERS TO MEL, ALWAYS.

Acknowledgments

- **Alex Miller**—not just Mel's son but best friend; many of our joys in watching him grow up into the amazing man that, of course, was Mel's son.
- **Emily Miller**—not just daughter-in-law but daughter—for being the glue, for supporting Alex, for starting the Miller Strong group, and for being such a spark of sunshine for Mel and Alex and whomever she met.
- **Peggie Correll, Mel's mother**—for raising such an amazing woman.
- **Mel's family**—for sharing stories and supporting this book.
- **Lori Fike English**—for your hilarious and spot-on bullet points that inspired this book.
- **Lisa Speer**—for having Mel as a guest on her *Branding BFF* podcast, preserving her voice and her laugh for future generations to hear.
- **Trish Saemann**—for writing About Mel
- **LeeAnn Shattuck**—for gathering and compiling all the thoughts, stories, and lessons about Mel, and for having the crazy idea to write this book in the first place.
- **Sherré DeMao**—sounding board and editor for the book.
- **Fabi Preslar and team at SPARK Publications**—for the book's design, production, and publication.
- **Cass Bradley of BlueSky Photo Artists**—for the beautiful and fearless portraits of Mel, and for sharing her notes from Mel's empowerment session which comprise the conclusion of this book.
- **Ebony Stubbs of Rae Images, Business Sorority's "historian"**—for her photographs of Mel and Business Sorority.
- **Everyone who contributed to the book**—Becca Bazzle, Sherre' DeMao, LeeAnn Shattuck, Nicolette Shoop, Kelly Byrnes, Angela Sherrill Simcox, Tammy Rojas, Trish Saemann, Jenni Miehle (thank you for the proofing eagle-eyes), Terri DeBoo, Ebony Stubbs, Lisa Speer, Lori Fike English, Lianne Hofer, Kirsten Aymer, Dr. Arielle Heeke, Claudia Abbott, Sintha Steward, Julie Tache, Peggie Correll, Laura Correll Taylor, Emily Miller and Alex Miller.
- **Mary Roberts and Angela Sherrill Simcox**—for continuing to honor Mel's vision and legacy of Business Sorority.
- **Nicolette Shoop**—for showering love on Mel's beloved trio of dogs.
- **Dr. Arielle Heeke**—Mel's oncologist at the Levine Cancer Institute—for helping Mel to fight the good fight.
- **And to Mel, for being our person.**

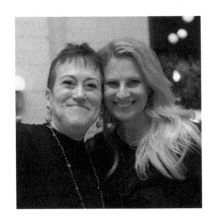

LEEANN SHATTUCK, a.k.a. The Car Chick®, is an automotive expert, speaker, writer, radio & television host, and champion race car driver. LeeAnn owns a unique car buying service that helps women and smart men get a great deal on the Perfect Car™, without all the crap that comes with traditional car shopping. LeeAnn is one of the founding sisters of Business Sorority and suggested the name to Mel one night after a few too many adult beverages. During Mel's memorial service, LeeAnn swears that she heard her best friend's voice voluntelling her write this book to keep Mel's legacy alive.

LeeAnn can be reached through her website, **TheCarChick.com**.

SHERRÉ DeMAO considered Mel a kindred spirit and confidante over their 20+ year friendship and was impassioned to help Mel's legacy live on! Founder of BizGrowth Inc, her award-winning firm specializes in next-level, next-idea solutions for entrepreneurs to build companies that ignite prosperity for all. She has been featured in *Huffington Post's* Thrive Global as a Woman of the C-Suite. Her book, *Dream Wide Awake* was selected for the National Association of Women in Construction's Leadership Book Club. **Bizgrowthinc.com**.

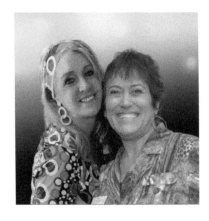

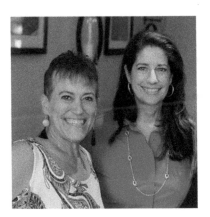

FABI PRESLAR founded SPARK Publications in 1998 to publish magazines and non-fiction books for business owners to help them share knowledge and stories to grow their businesses and to positively help transform the world. Mel and Fabi kept pushing back their lunch date, as they both were going through treatments for breast cancer. When Fabi heard LeeAnn's idea for this book, SPARK Publications' services were gifted to honor Mel. That day they were to spend together will forever be celebrated in the times where this book brings smiles and moments of bold wisdom.

SPARKpublications.com.

SPARK PUBLICATIONS

#belikemel

To order additional copies of this book go to businesssorority.com

CPSIA information can be obtained
at www.ICGtesting.com
Printed in the USA
LVHW072318231021
701344LV00002B/30